Renoir

Colin Hayes

Renoir

The Colour Library of Art
Paul Hamlyn·London

Acknowledgments

The paintings in this volume are reproduced by kind permission of the following collections, galleries and museums to which they belong: Art Institute of Chicago: Bequest of Kate Brewster (Figure 4); Ashmolean Museum, Oxford (Plates 38, 42); Sir Kenneth Clark Collection, London (Plate 31); Courtauld Institute Galleries, London (Plates 4, 36, 41, Figure 8); Cummings Collection, Chicago (Plate 46); Lehman Collection, New York (Plates 23, 24, 34); Lopez Collection, Algiers (Plates 29, 30, 33, 44); Musée du Louvre, Paris (Plates 1, 2, 3, 6, 7, 9, 10, 17, 25, 27, 48, Figures 2, 3); Musée des Beaux-Arts, Lyons (Plate 19); Musée National des Beaux-Arts, Algiers (Plate 13); Musée de l'Opéra, Paris (Plate 37); Musée de Peinture et de Sculpture, Grenoble (Plate 43); Petit Palais, Paris (Figure 5); Trustees of the National Gallery, London (Plates 15, 16, 40); Trustees of the National Gallery, London: Lane Bequest (Plate 14); Phillips Collection, Washington (Plate 5); National Museum of Wales, Cardiff (Plate 18); Private Collection, Algiers (Plate 47); Private Collection, Geneva (Plate 28); Private Collections, Paris (Plates 8, 11, 12, 21, 22, 26, 32, 39, 45); Rouart Collection, Paris (Plate 20); Trustees of the Tate Gallery, London (Plate 35, Figure 9); Victoria and Albert Museum, London (Figures 6, 7). The following photographs were supplied by Giraudon, Paris (Plates 1, 2, 3, 6, 7, 8, 9, 11, 13, 17, 18, 19, 20, 21, 22, 23, 24, 25, 26, 28, 29, 30, 33, 34, 36, 37, 39, 43, 44, 45, 46, 47, 48, Figures 1, 2, 4); Andre Held/Joseph P. Ziolo, Paris (Plates 4, 10); Michael Holford, London (Plates 27, 31, 41, Figures 5, 6); Raymond Laniepce, Paris (Plate 12).

Published by Paul Hamlyn Limited
Drury House · Russell Street · London WC2
© Paul Hamlyn Ltd 1961
Printed in Italy by Officine Grafiche Arnoldo Mondadori, Verona

Contents

Introduction

PIERRE AUGUSTE RENOIR was born at Limoges on February 25th 1841. His father was a small tailor, who, apparently to provide future scope for his sons as well as for himself, moved with his family to Paris when Renoir was four.

His parents had a taste and care for *objets d'art* which was not uncommon among the *petite bourgeoisie* of that generation, and his own recollections make it clear that he grew up in an atmosphere in which the prospect of becoming an artist in some humble capacity did not seem impossible. His mother would point out the beauties of the scenery on their walks through the woods at Louveciennes, and when he went to school in the Rue d'Argenteuil he found himself being taught singing by no less a person than the yet unknown Gounod. His family talent for drawing already showed itself, and at thirteen (his brother was an heraldic engraver) his parents found the opportunity to apprentice him to a china manufacturer.

This was a time when common china was still hand-painted in conditions that we would call sweated labour. Renoir painted floral patterns and bouquets on pieces of ware at the rate of five sous a dozen, becoming promoted, as he gained in skill, to profiles of Marie Antoinette.

Although he did not at this time look forward to any other career it clearly did not satisfy him: he soon started going to evening drawing classes and paying regular visits to the Louvre, where he was struck by sixteenth-century sculpture, and by the paintings of Boucher.

This was still the Paris which had not been transformed by Haussmann, and the Boulevard du Temple where Renoir worked was in one of the liveliest districts of the city. It was something of a perpetual fairground, full of the noise of pedlars, street performers and idlers exchanging badinage among the market trestles. All this the young Renoir enjoyed, as he did the *théâtre populaire*, with its naive melodramas. His biographer and friend, Georges Rivière, tells how he

never lost his love for such pieces as *Le Bossu* and *La Dame de Montsoreau* where the good end happily and the wicked are always punished: he enjoyed them as he enjoyed the Parisian crowd, and his sympathy for popular life emerged in all his work. He grew up too much of the people ever to see them with the ironic detachment of Degas. It is not fanciful to suppose that already, in his visits to the Louvre, he recognised the living scene about him transposed into the ideal in the Bouchers, Watteaus and Fragonards which he was soon to have to copy for a living.

Renoir's ambition was to enter the factory at Sèvres as a porcelain painter, but his prospects were unexpectedly dashed. 'At the end of four years' apprenticeship,' he told Vollard, 'just as I saw opening before me at the age of seventeen the magnificent career of painter on porcelain at six francs a day, there befell a catastrophe which ruined my dreams for the future.' The mechanical printing of designs on chinaware was just being introduced, and the new process caught on at once with the public. The hand-painted product was now considered too rough, and at any rate could not compete at the price: Renoir's employer shut up shop, and the young man was compelled to take to painting fans for a living. Suitable subject matter lay at hand in the copies he had already made of Watteau, Lancret and Boucher.

In such employment, first with his fans and then with the decorations of blinds, he saved enough money to take a new step in his life. He had begun to experiment with oil paint at the china works; now the urge to continue became insistent.

Despite the qualms of his family, and encouraged by his friend Laporte, he threw up his job with the blinds manufacturer and entered the studio of Gleyre. At this free and easy establishment there was little teaching; for this, Renoir went to evening classes in life drawing and anatomy at the École des Beaux-Arts. However, students were free at Gleyre's

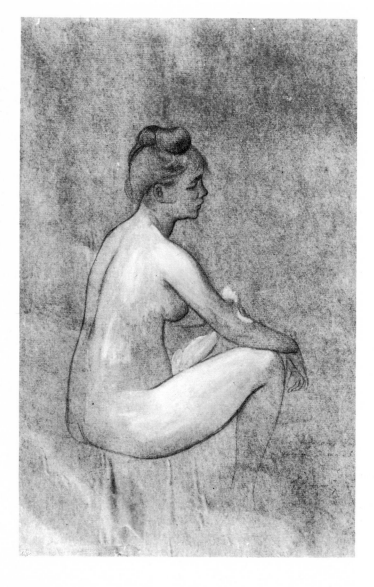

studio to follow their own bent, and Renoir was fortunate in meeting there three fellow students, Monet, Bazille and Sisley. These three had already come into contact with the Realist movement: Monet had come to Paris from Le Havre with the encouragement of Boudin, while Sisley and Bazille were admirers of Corot and Courbet. It is significant of Renoir's future development that his recognition of the revolutionaries in this student period did not incline him to Monet's pre-occupation with landscape; not only did he prefer the figure, he retained his enthusiasm for the work of the Old Masters, and it was he who would insistently drag the reluctant Monet round the Louvre.

With the closing of Gleyre's studio, the group embarked on that poverty-stricken but adventurous period of the sixties which carried them from Realism to the first essay of Impressionism. They painted woodland scenes in the forest of Chailly, Renoir meeting rural nature as a subject for the first time; he was working still in the light of Corot and Courbet. As the future Impressionist group drew together, Renoir met not only such men as Diaz and Courbet but also Manet, Pissarro, Cézanne and his friend Zola.

In their submissions to the Salon the friends were generally unsuccessful, but before 1870 Renoir had some half dozen pictures accepted at the Institution whose approval was still the foundation of a young painter's career. His portrait *Lise* and his group picture *At the Inn of Mother Anthony* are among the best known of his works from this time, and although they are Realist in conception, the influence of Manet, with his bold areas of flat colour, is noticeable. *Portrait of Frédéric Bazille* (plate 1), painted in 1868, shows that readiness to accept the scene before him which is characteristic of Degas' portrait of Tissot, done in the same year; it even makes Manet's *Emile Zola* of 1868 seem a little posed.

With his portraits and figure studies Renoir attracted

2 *Baigneuse*. Drawing. 13×9½ in. (33.5×24 cm.). Musée du Louvre, Paris

some attention; Bürger the critic noted of *Lise*, 'The effect is so natural and so true that one might very well find it false, one is so accustomed to nature represented in conventional colours.' But although his personality begins to show itself in these paintings, it is in the canvases which he set up alongside Monet at the Café de la Grenouillère on the banks of the Seine that we can see the stirrings of his new vision. Here his eye was no longer half on Courbet, but all on nature, in those rapidly brushed evocations of light and shadow playing on rippling water and of Parisian trippers caught in conversation under the trees.

These pictorial adventures, and the few portrait commissions that came his way, were interrupted by the Franco-Prussian War. The circle which had been accustomed to foregather at the Café Guerbois was dispersed. While Monet and Pissarro and several other painters ended up in London, Renoir found himself in the cavalry at Bordeaux and the Pyrenees. ('I could nail down ammunition boxes like no one—my captain found that I possessed the military spirit and wanted me to continue the profession of arms. If I had engaged in all the careers people have encouraged me to take up!')

After experiencing the rigours of the Commune which followed defeat, he settled again in Paris to search for portrait commissions and to paint the scenes which enchanted him at heart more than the tranquillity of the countryside. His brother Edmond is said to have been engaged by him to stand on the Pont Neuf and stop passers-by with unnecessary enquiries, while Renoir, from a second-floor window, used them as unwitting models for his crowd scenes.

His true individuality emerged with the First Impressionist Exhibition of 1874. By this time he had had the good fortune to interest Durand-Ruel, the dealer who championed the Impressionists for many years almost single-handed. His purchases enabled Renoir to take a studio in the Rue St Georges and to set about the reconciliation of his belief in tradition and his excitement with his new chromatic discoveries.

In *The Theatre Box* (plate 4), the masterpiece among his exhibits at the show of 1874, we can see his problems resolved. From the time of this painting, both the direction of his vision and his stylistic development seem to have been assured. But, if there is truth in André Lhôte's saying that 'great painters paint in order to learn to paint', it was most certainly true of Renoir at this moment; for it was now that he, with Monet and Manet, entered upon the series of river scenes at Argenteuil. The Argenteuil landscapes of 1874 and 1875 are perhaps the high water mark of true Impressionism at its happiest moment.

In opening this new world of visual appearances at Argenteuil, Renoir and Monet abandoned not only their remaining allegiance to the old order of subfusc tonality with their chromatic rendering of values, but freed themselves from the tyranny of the linear contour. Adopting a small 'comma' brushstroke, they evoked their forms from an interlocking surface of small clear marks, blending their colours not by mixing them on the palette but by placing their constituents side by side on the canvas.

Along with the well-known effects of atmospheric vibration and sunlight which they thus obtained, they achieved two results which are not always given their due importance when Impressionism is spoken and written of as a thing of the past. First, the revelation of atmospheric reality in the pictures gave the spectator a sensation of actual presence in the picture which no painting had ever quite achieved before in the same way: the reality of Rembrandt, by contrast, gives one the feeling of being rather in the same room with Jan Six than in the same picture. Secondly, this veil of atmosphere through which the objects of nature were evoked, transformed the objects themselves in a new way. If factory chimneys and box-girder bridges had generally been avoided by former painters

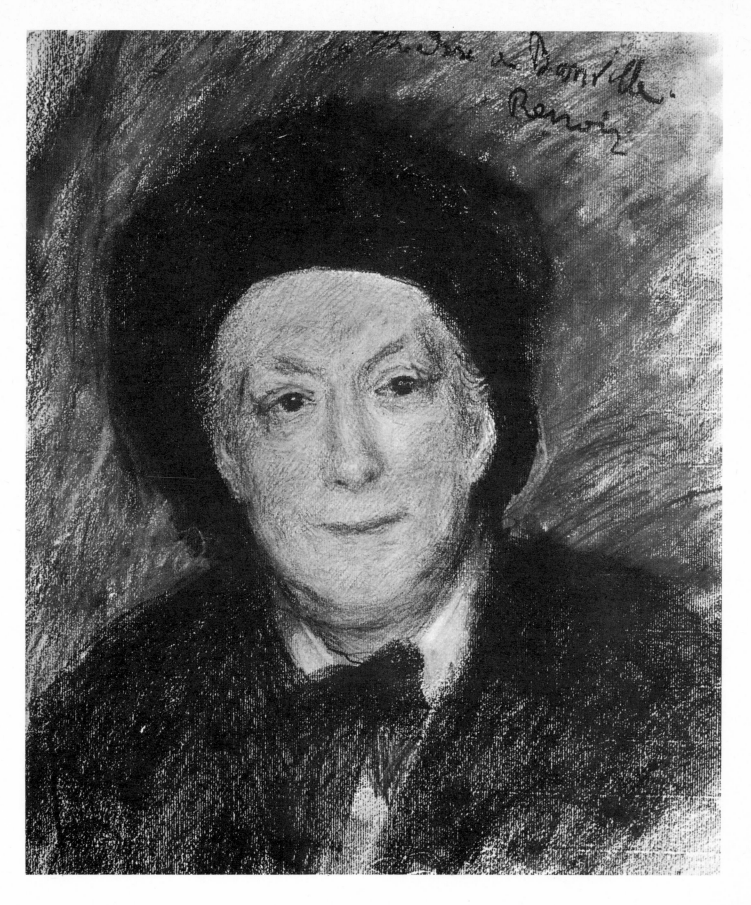

it was because they were frankly ugly. But through the air of a summer evening or a squall of rain they can be beautiful, and Renoir with his companions made them beautiful. By this act the naturally beautiful was made redundant; Impressionism, in these months of 1873 and 1874 dealt the final death blow to the old picturesque. Both these effects had their profound influence on subsequent painting.

Among these classic Impressionists Renoir was now exceptional in bending the new faculties of liberated colour and transformed substance to the main task of painting the figure, though 'task' seems an inappropriate word to associate with the apparent ease and assured style in the canvases of his new maturity. *The First Outing* (plate 16), *The Swing* (plate 3), *Le Moulin de la Galette* (plate 2) and many studies of models clothed and nude were painted in the mid-seventies. Renoir would sit at the Café de la Nouvelle Athènes making drawings and paintings of the Place Pigalle (it was here that Degas placed Desboutin and Ellen Andrée in his famous café portrait *L'Absinthe*). Manet and Degas had now made it their evening headquarters in succession to the Café Guerbois; together with Renoir they were the habitués at the tables to which other members of the group came when they could, as well as such critics and writers as Duranty, Villiers de l'Isle-Adam and the young George Moore. Moore's strongest recollection of Renoir at the Café de la Nouvelle Athènes was the passion with which he denounced the nineteenth century for its destruction of craftsmanship and for its vice of imitating the antique.

Of his paintings of the 1870s it is *Le Moulin de la Galette* which is not only the masterpiece, but which seems to sum up his art and his life at this time. As Courbet's *Studio* was autobiographical, so is this work of Renoir; but where Courbet had posed his models, his friends and the elements

3 *Portrait of Théodore de Banville*. Chalk. 20½ × 16¼ in. (52 × 41.2 cm.). Musée du Louvre, Paris

of his life about him in his studio, with the self-conscious flourish of a *maître*, Renoir saw such things in their familiar element of the open-air dance of Montmartre, and he kept them there. He paints his circle, not paying him homage, but enjoying itself.

The Impressionist Exhibitions of 1874 and 1876 brought Renoir the same scorn that was suffered by the other participants, but after a sale at the Hotel Drouot he had the good fortune to meet Victor Chocquet, a customs supervisor who collected works by Delacroix and who became his first true patron. Chocquet commissioned him to paint portraits of himself and his wife, and over the next twenty years bought many of Renoir's paintings. It was characteristic of Renoir that he at once introduced Chocquet to Cézanne; the collector's enthusiasm for him became even greater than for Renoir.

Now, unlike Pissarro, Monet and Sisley, Renoir began to have some success. In 1878 he was accepted at the Salon where he sent *La Tasse de Chocolat*.

'My submitting to the Salon is entirely a business matter,' he said in self defence, '. . . like certain medicines: if it doesn't do any good it doesn't do any harm.'

Moreover he had got to know the liberal publisher, Georges Charpentier and his wife. Mme Charpentier was well known among the *haute bourgeoisie* for her literary salon. Renoir, painting portraits of the Charpentiers and their family, found himself involved with the fashionable world of letters, and it was not altogether to his taste. But more important to him than meeting such men as Maupassant, Huysmans, Mallarmé and even once Turgenev, were the commissions which began to come in.

In a modest way he was becoming a fashionable portrait painter, a potentially perilous situation, which, however, never seriously affected his integrity as an artist. Indeed, in the ten years between 1875 and 1885 the fine and sympathetic

commissioned portraits he painted stand equally beside the more private studies of his fellow artists, his landscapes and nudes. In his *Luncheon of the Boating Party* of 1881 (plate 5), with its acknowledgment of Veronese in its splendid light and movement, came a final grand reaffirmation of *Le Moulin de la Galette* and his bachelor life. His fiancée posed for him in this picture, and he married her in the same year.

He had already made a trip to Algeria in 1879 for six months, where he painted a number of canvases. Financial improvement, his marriage and perhaps the mature consistency of his work, prompted him to take stock of himself in the interruptions of travel. After a stay in Guernsey (he seems to have been impressed by *ces protestants anglais* who bathed naked, according to him, as a matter of course), he left Paris for Italy with his wife in 1881. He visited Rome, where he painted nudes of his young wife—Florence, Naples and Venice, where he painted the famous scenes and, like so many, discovered Carpaccio with unexpected delight. At Palermo he painted a twenty-five-minute portrait of Wagner. Italy impressed him through Veronese, Donatello and especially Raphael, whose frescoes in Rome made him question his own art with their simplicity and inevitability. 'Unlike me, he did not seek the impossible . . . I am like children at school. The white page must always be nicely written and bang—a blot. I am still at the blotting stage—and I'm forty.'

After his return from Italy he remained restless and became increasingly dissatisfied with his own work. Visits to Cézanne at L'Estaque, where his solitary-minded friend was now resolving his quest for a chromatic architecture of painting, may well have increased his suspicions that Impressionism had led him astray from the quality of classicism which he now felt necessary to his work. He had with some reluctance contributed to the Seventh Group Exhibition of the 'Independants'. Irritated by the non-conformism of the title

which Degas had given the group, Renoir wanted to reserve the moral right to go his own way and exhibit at the Salon if he chose.

His trip to the Côte d'Azur with Monet in 1883, though they were still as friendly as ever, no longer seemed to have the artistic excitement and justification of former years. He preferred to work alone.

'I had come to the end of Impressionism and had arrived at a situation in which I did not know how to paint or to draw. In a word, I was at an impasse.' This is how Renoir later described to Vollard his state of mind at the end of 1883.

Feeling that the open-air preoccupation with light had seduced his attention from form, he now turned his mind to the museums, to his studio and to the need for a change of style. Too instinctive and natural a painter to submit his art to an absolute doctrinaire change, Renoir shows us no sudden break in the manner of his work from this time, but by 1885 we find him painting in what is known as his 'sharp manner'. He had in 1884 begun his large *Bathers*, which became something of a testing ground for his classical power. More elaborately preceded by drawn studies than most of his paintings, it was not finally ready for exhibition until 1887. In this mood Renoir consciously deprived himself of some of his characteristic soft charm; he went, as it were, back to school with himself. His work of this period becomes concerned with sharply defined linear outline and, by Impressionist standards, a high degree of 'finish' in the matter of descriptive detail. His portrait of Suzanne Valadon (the young model who was to establish her own name as a painter, and become the mother of Utrillo) is a characteristic example.

The work of his 'sharp manner' still to some extent suffers the critical unpopularity which was not so long ago shared by the 'finished' landscapes of Constable, but Renoir's best works in this genre, like Constable's, have a power which comes from qualities more profound than the mere elabora-

tion of a sketch. These paintings are in fact most successful where they are most uncompromising; only where he half turned his mind back to the charms of the open air does the mixture of classic line and luminous sensation become a little unhappy and uncertain.

The discipline to which Renoir subjected himself was far from wreaking the destruction on his art which George Moore was to complain of, and if it seems out of keeping with his artistic nature we should accept is as a necessary element in those richest products of his working life which were yet to come. Renoir seems to have regarded this period not so much as an intermezzo but as an essential restorative which enriched rather than interrupted the main stream of his art. It was perhaps his visit to Spain in 1886 that gave an impetus to his development. He enthused before the masterpieces in the Prado and it is a pleasant supposition that Velasquez helped to enlarge Renoir's vision just as Rubens in Spain had enlarged the vision of Velasquez himself.

Renoir, unlike the almost ignored Cézanne, was now a success. He settled down with his family. By this time, around 1890, the cohesion of the Impressionists had long vanished, and the old guard was physically dispersed. Paris did not suit Renoir's health, and during the nineties he spent much time away from the city, travelling to England, Holland and Germany, even visiting Gauguin and his band of disciples at Pont Aven.

When Ambroise Vollard first went to call on Renoir in 1894, he was stopped at the door by Mme Renoir's maid, Gabrielle, because the other maid, who modelled for *La Boulangère*, had forgotten to put out the doormat. The qualification for a maidservant-cook in the Renoir household was that she should have a beautiful skin. Gabrielle and 'La Boulangère', whose duties alternated between the kitchen, the nursery and the model's couch, have become the most celebrated artists' models of modern times. He painted many canvases of them, nude and clothed, sometimes as symbols of womanhood, sometimes in their domestic roles with the children. Their images, with those of his wife and children and the southern landscapes of Cagnes, where they went to live after 1903, form together the sublime flowering of Renoir's art. He now made paintings whose style was so assured that it no longer seemed to enter consciously into his thoughts. He had achieved that prerogative of mastery where everything can be made real though nothing is imitated.

It is a sign of Renoir's total devotion to the practice of painting that the mood of his work shows no sign of the physical affliction that was to curse the last twenty years of his life. The onset of arthritis in the 1890s forced him, by 1903, to live almost entirely at Cagnes in the Midi. There were periods when Renoir, who had hardly missed a day's painting in his adult life, could not work at all. By 1910 he was in a wheel-chair, unable to use his fingers, though characteristically he surmounted his limitations to the extent of experimenting in sculpture, directing with a long stick two young craftsmen in the actual application of the clay he could not handle. But the great canvases of his last years are proof enough that painting is not a matter of manual dexterity. With brushes strapped to his wrist with sticking plaster he continued to paint, and, like Rembrandt and Titian before him, like Bonnard after him, he drew from his talent in old age yet a new phase in his painting.

He was a lucky fellow, he said, not to be nearly blind like poor Degas, and he used his sight in producing a series of primitive nudes and bathing groups of brilliant visionary warmth. These last triumphs of invention made him, in the age of Cubism and the Futurists, suddenly a new figure of praise and controversy, a 'contemporary'.

He died in 1919, painting almost to the last day of his life.

Biographical outline

1841 Born Limoges.
1845 Family moved to Paris.
1854 Apprenticed to china manufacturer.
1856 Paints fans, blinds and murals in bars.
1859 Earns money to become an art student.
1862 Enters Gleyre's Academy. Meets Monet, Sisley, Bazille. Works at École des Beaux-Arts.
1863 Works for his brother, a metal engraver. Decorates a café in Rue Dauphine.
1864 Working in Chailly. Meets Diaz. Accepted at Salon. Later destroys picture *Esmeralda*, painted in bitumen.
1865 Accepted at Salon. Lives at Marlotte.
1866 Rejected at Salon. Paints *Le Cabaret de la Mère Anthony*.
1868 *Lise* accepted at Salon.
1870 Accepted at Salon. Called for military service. Bordeaux. Pyrenees.
1871 In Paris during Commune. Paints portraits.
1872 Lives in Paris. Studio in Rue Notre-Dame-des-Champs. Rejected by Salon. Paints urban scenes. Visits Monet at Argenteuil.
1873 Meets Durand-Ruel. Studio in Rue Saint-Georges.
1874 First Group Exhibition. Plays active part. Seven works shown. Stays with Monet at Argenteuil. Meets Caillebotte. His father dies.
1875 Meets Chocquet. *The Swing*. Begins *Le Moulin de la Galette*.
1876 Second Group Exhibition. Fifteen works shown.
1877 Third Group Exhibition. Shows twenty-one works.
1878 Paints near Dieppe.
1879 Success at Salon with portrait of Mme Charpentier. Meets Paul Bérard.
 Does not send to Impressionist Group Exhibition.
1880 Does not send to Impressionist Group Exhibition.
1881 Visits Algeria. Marries Aline Charigot. Travels in Italy.

1882 Exhibits at Seventh Group Exhibition.
1883 Exhibition at Durand-Ruel.
1884 Turns from Impressionism. Beginning of 'sharp manner'.
1885 Pierre born.
1886 Refuses to show with Group. Work exhibited in New York.
1887 Visits and works with Cézanne at the Jas de Bouffan. Neuralgia partly paralyses him. Success of *Les Grandes Baigneuses*.
1889 Visits Cézanne.
1890 Exhibits at Salon after seven years.
1891 Visits Berthe Morisot.
1892 Large one-man show. Visits Pont Aven.
1893 Jean born.
1894 Caillebotte dies. Renoir executor of bequest to Musée du Luxembourg.
 Meets Vollard. Attacks of arthritis.
1895 Probable year of visit to England and Holland.
1896 Exhibition at Durand-Ruel.
1897 Six Renoirs admitted to Musée du Luxembourg from Caillebotte bequest.
1898 Buys house in Burgundy.
1899 Suffers badly from arthritis.
1900 Made *Chevalier de la Légion d'honneur*.
1901 Claude born.
1903 Lives in Cagnes.
1907 Takes up modelling.
1910 Journey to Munich. Confined to wheel-chair.
1912 Illness. Paralysed for a time.
1913 Bernheim exhibition of forty-two Renoirs.
1914 War. Pierre and Jean in the services.
1915 Jean Renoir wounded. Mme Renoir dies.
1919 Visits Essoyes and Louvre; returns to Cagnes. Dies, 17th December, aged 78.

A note on Impressionism

When, in 1874, the *Société Anonyme des Artistes, Peintres, Sculpteurs et Graveurs* held its first exhibition at the studio of the photographer Nadar in Paris, the critic Louis Leroy aimed at it a blast of rage and ridicule, in which he gave a farcical description of an academic painter being driven to insanity by a visit to the show. His article in *Charivari* he entitled, scornfully, 'Exhibition of the Impressionists', a word he picked from Monet's painting *Impression-Sunrise*; and it was the thirty-three year old Auguste Renoir, a principal organiser of the venture and himself exhibiting seven works, who afterwards insisted on retaining the name by which he and his associates have ever since been known. The title, Renoir explained, made it clear to the public—'Here is the kind of painting you won't like: if you come in, so much the worse for you—you won't get your money back!'

Some among those historians and amateurs of art, who like to see their artists neatly pigeon-holed, have questioned whether or not Renoir may be called a 'true Impressionist'; they have asked this same question about Manet, Degas, Cézanne, Gauguin, Seurat and van Gogh, admitting without cavil only Monet, Pissarro and Sisley.

The Impressionists themselves indeed seemed full of doubts. Well aware of their own individualities of character and talent, they veered in their internal enthusiasms and antipathies—Degas not wishing until later years to be associated with Cézanne, Manet not always wishing to be associated with the group at all. It may seem surprising that painters so different from one another should have adhered together so much and for as long as they did: seeing their work as we now so easily do, in isolation from their period, we may wonder if the term 'Impressionism' is not something of a convenient historical portmanteau word. But a glimpse of a work by an official Salon painter of the period will provide

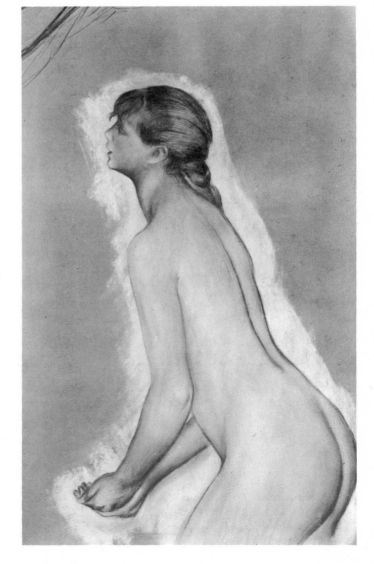

4 *Nude, Study for 'The Bathers'*. Pencil. 38¾ × 25¼ in. (98.5 × 64 cm.). The Art Institute of Chicago. Bequest of Kate Brewster

one adequate clue. The paintings of the Impressionists may have been varied, but taken as a group they were startlingly different from anything else the public of their time was accustomed to. The picture-going, and more particularly the picture-buying public drew its standards of pictorial excellence from the exhibitions of this Salon, which in the mid-nineteenth century largely dominated the careers of French painters.

When the young Renoir, Monet and Sisley began to work together as students in the early 'sixties, these standards were vulgar, decadent and artificial, a pander rather than a guide to public taste. Of course from a positive view the older Impressionists were alike in having embarked on the course of painting, not only with great talents, but with rare discernment, understanding the heritage of the Old Masters, to whom the Salon and the public paid lip-service; but there is no doubt that the banal fortress of official art and official selection juries, and the rarity of their acceptances by the Salon, did much to force them together. Also their common situation led them to regard themselves in varying degrees as disciples of those few older masters in the world of French nineteenth-century painting who stood apart from the Salon standards. Among these the oldest and most distinguished figure was Ingres, aged eighty in 1860, but his adherence to classical ideals and his lack of interest in change and development had made his tyrannical linear teaching in some degree responsible for the lifeless and empty subject pictures of accepted painting. He was respected for his personal stature by all, but only Degas was to make a hero of him.

It was the Romantic Delacroix, born eighteen years after Ingres (his great rival), whom the young future Impressionists watched secretly at work in his garden from a window across the street, and of whose *Women of Algiers* Renoir said that there was not a more beautiful painting in the world.

In Courbet, the non-conforming and self-confident rebel,

whose private *Pavillon de Réalisme* had stood in rivalry to the official display of paintings at the Paris World's Fair of 1855, they found a more immediate rallying point. Courbet's bohemian attitudes, his statement that 'the beauty presented by nature surpasses all the conventions of the artist', and above all the forceful connection of his unrefined paintings with real life were a recognisable challenge to the approved make-believe canvases of pseudo-classicism.

Renoir and his friends were to discover as well the example of the lately recognised Corot (a true classic master), of Millet and the Barbizon painters Daubigny and Diaz. They were all excited by the exotic and unexpected design of the lately arrived Japanese prints.

What quality of attraction did such exemplars have in common to inspire and enthuse? Above all they were painters who had observed in front of nature, and had expressed, whether in the human figure or in landscape, indoors or out, something of nature's truth.

Delacroix had enlarged his vision with the discoveries of Constable, Corot had given a unique reality to his formally designed landscapes, and the Barbizon painters had worked for many years out of doors before the subject.

In the 1860s the new group, consisting of Renoir, Monet, Sisley, Bazille, Degas, Pissarro (and intermittently Cézanne) coalesced more or less under the leadership of the sometimes reluctant Manet. The most sophisticated and, after Pissarro, the oldest of them, he was also the most mature painter and was even beginning to gain some notoriety.

They shared, then, the same classes, the same enthusiasms and much the same personal hardships. They shared too the common aim of discovering their talents in the life that lay about them.

To begin with, however, they were content to explore according to such examples as Courbet, Boudin and Daubigny. It was not perhaps until the re-gathering after the dispersal

of the Franco-Prussian War (in which Bazille was killed) that the ideas which had been germinating in their minds bore full fruit. In their choice of subject matter many had already gone beyond any of the older painters in the daring with which they pounced upon the actual scene unawares, and it is clear, as much in the development of their work in the late sixties as in their later recollections, that they were feeling the need for a new way of painting to match their new vision.

A number of painters from Constable onwards have been hailed as originators of Impressionism, but it is difficult not to accord to Claude Monet, in close association with Renoir, the credit for having found the way of rendering forms seen through the actual veil of natural atmosphere, which is the characteristic discovery of the movement.

At Bougival, in 1868, Monet and Renoir had already begun to find that the shimmer of atmosphere could be expressed in a fragmenting of the smooth surface with broken brush marks. At Argenteuil, shortly after the war, the same pair painted similar scenes with a new radiance of light and colour. The transition had long been a theoretical possibility. Chevreul's famous treatise on colour had been known to Delacroix, but its application to painting had been misunderstood, not least by Chevreul himself. This director of the Gobelins tapestry factory had formulated the law of 'Simultaneous Contrast', which pointed out that one colour tends to throw its own complementary or opposite upon the colour next to it. Thus a crimson red will tend to throw upon a neutral grey next to it a greenish blue tinge, while a yellow will make the same grey seem violet—a fact which can easily be verified with a few pieces of coloured paper. Monet and Renoir saw that this effect indeed occurred in nature, and that shadows cast round green trees or among blades of grass seemed by contrast violet. Gone was the need to render shadows always by the sharply darker tones which

had lent their work of the 'sixties a somewhat harsh look; the effect of shadow, and therefore of form, could be achieved by contrasts of colour. Since this kind of colour had suddenly become an observable phenomenon of nature (now that their eyes had been opened to it) it admitted to their canvases a transformed and enhanced reality of light and air. Moreover, since degrees of white and black need no longer be reserved for the explanation of light and shade, they could be restored to their primitive duties of explaining white blouses and black coats.

The instinctive quality of this discovery gave to the work of the group a few years of the joyful, uninhibited and unworried transformation of nature into paint which characterised classic Impressionism.

It was not the public scorn of their joint exhibitions which caused the break-up of these painters as a group after the 1870s, but their own natures. The private quarrels and dissensions destroyed few of their mutual friendships, but their dynamic qualities of invention led them inevitably into separate paths—some like Monet, Pissarro and Seurat, into attempts at systematic order, some, like Sisley, into artistic decline, some, like Cézanne and Renoir, towards the subordination of Impressionism to a personal vision of humanity.

Writings and comments on art by Renoir

The following extracts are from an introduction by Renoir to a translation of Cennino Cennini's *Il Libro dell'Arte*, which was published in France in 1911. Cennini's book, written in the fourteenth century, is perhaps the earliest treatise on the technique of painting, and it is a valuable document on the tradition of the Early Renaissance.

. . . A curiosity, did I say? This book of Cennini's deserves a better epithet than that. It contains many lessons which are of more value than the counsels one occasionally hears: moreover, it is illustrated with examples chosen from among the author's contemporaries, and that gives it the flavour of old memoirs brought to life again . . .

We must remember to live according to the forms we have inherited; it is no longer necessary to pretend, in the name of progress, that we can detach ourselves completely from bygone centuries. This is, nevertheless, a tendency which we see all round us, and it is easy to explain. So many wonderful discoveries have burst upon the world in the last hundred years that men in their astonishment can easily forget the existence of others who have lived earlier.

It is therefore well that there should be a man like Cennini to remind them that they had ancestors whom they had no need to despise.

The treatise of Cennini is not only a manual of technique, it is also a history book which tells us not of battles or court intrigue but which introduces us to those master craftsmen through whom Italy has acquired the purest glory, just as Greece and France have done through theirs. If they did not always make a fortune or leave a name, they enriched their country with a priceless treasure, and gave it the likeness by which we can distinguish it from other countries.

One must insist it is the whole body of works left by numerous artists forgotten or unknown which forms the greatness of a country, and not the original works of a man of genius. These latter, isolated among their contemporaries, cannot often be contained within a frontier or an epoch; they pass such things by. The former, on the contrary, incarnate at the same time an epoch and a territory . . . We may acknowledge the glory which connected Raphael, Titian, Ingres and Corot to their period and place, without having the pretension to write a treatise of painting for these exceptional beings. Those of whom the Italian master writes did not all possess genius, but they remain wonderful craftsmen . . .

In Cennini's time men decorated temples; today we decorate railway stations, and it must be acknowledged that our contemporaries are less well endowed with sources of inspiration than their forebears. But, above all, for the realisation of these collective works there existed an essential condition; it was this that gave them their unity. The painters were all practising the same craft. It is this craft that we none of us entirely know, because, since we were emancipated from tradition, no one has taught us.

Now the craft of these Italian Renaissance painters was the same as that of their predecessors. If the Greeks had left a painting treatise you may be sure it would be the same as Cennini's. All painting, since that of Pompeii made by the Greeks, through that of Poussin and up to Corot seems to come from the same palette. This manner of painting everybody learnt from their master, their genius did the rest. Moreover the apprenticeship of a painter of Cennini's time did not differ from that of other craftsmen. In the studio of the master he did not only learn to draw, he learnt to make brushes, to grind colours, to prepare panels and canvases. Little by little he was initiated into the technical difficulties of this daunting application of colours, as a faculty he could only acquire through experience prolonged from generation to generation.

5 *Berthe Morisot and her Daughter*. Pencil 23¼ × 17½ in. (59 × 44.5 cm.). Petit Palais, Paris

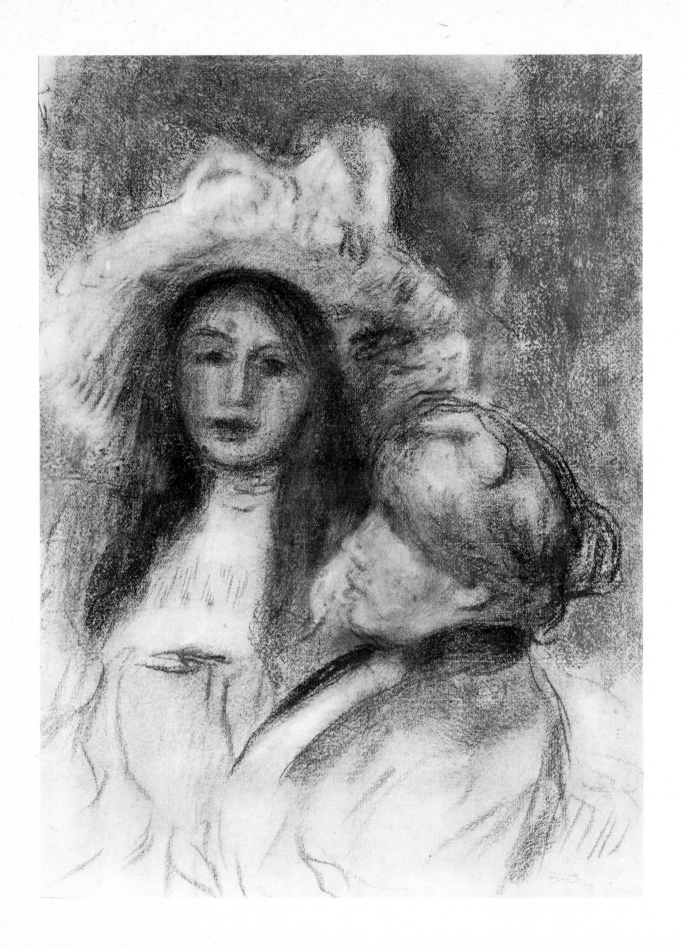

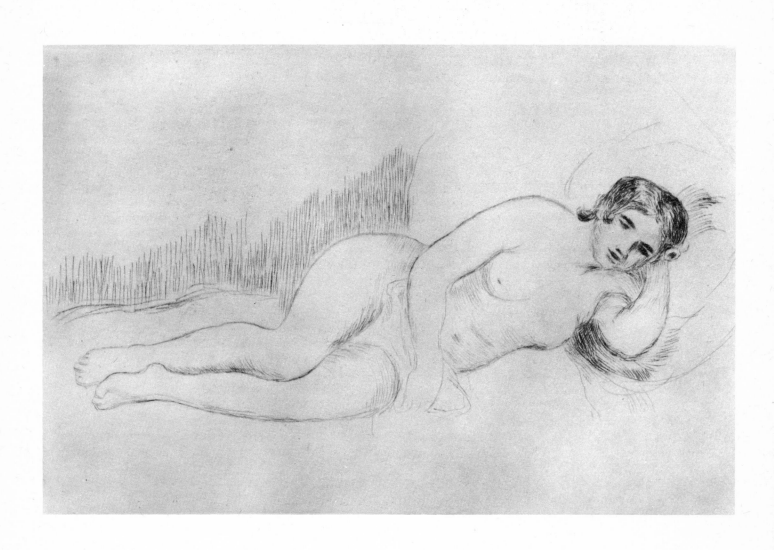

The severe apprenticeship of a young painter did not hinder his originality of vision. Raphael, the assiduous student of Perugino, nevertheless became the divine Raphael. But to explain the general force of the old art, we must remember that above the advice of the master there existed another thing which filled the souls of Cennini's contemporaries, and which had disappeared—that religious spirit which was the most fertile source of their inspiration. It is this which gives all their works that character of nobility and frankness in which we now find so much charm. In a word, there existed a harmony between men and the atmosphere in which they lived; this harmony came from a common belief . . . while we must concede that men saw heavenly society in the image of their own, it is more true that this divine organisation had in its turn a great influence on their spirits, and conditioned the nature of their ideal. Understanding this we can grasp the reasons for the general trend of their art and of its unity wherever a great religious conception reigned—in Egypt, in Greece, in western Europe: so much so that one could almost say that outside the range of such principles no art could exist.

The religious sentiment became enfeebled throughout the centuries, but the rules established under its influence rested on such solid foundations that up to the revolutionary period what remained of it was enough to maintain the grand direction of art among people of Catholic culture. I say Catholic culture purposely, because in our eyes it marks the essential difference between the ideas of beauty which this culture sustained, and those of the early Christian culture—anarchic, egalitarian and obsessed by ugliness. If Christianity had triumphed in its primitive form we would have neither beautiful cathedrals nor sculptures, nor paintings. Happily, the gods of the Egyptians and the Greeks were not quite dead;

6 *Femme Nue Couchée*. Drypoint 5½ × 7⅞ in. (13.7 × 19.9 cm.). Victoria and Albert Museum, London

by insinuating themselves into the new religion they saved beauty.

In the greatest epoch of its power, the Church, which in other respects was tyrannical, left the artists in an almost unlimited state of independence; the times themselves regulated their imaginations. They were able to draw upon profane sources without fear: under the Greek influence, soon reawakened and welcomed in Italy and France, the cultivation of beauty reappeared in the world and Catholicism gave it a new face . . . The most ordinary objects carried its imprint. It seemed in this happy time that everyone, however humble, carried in him the ambition to attain perfection. The smallest trinket revealed in its maker that purity of taste for which we search in vain in our modern productions. It must be noted, however, that together with the religious sentiment, other causes contributed a good deal to giving the old artisan those qualities which put him beyond compare. Such, for instance, was the custom that an object would be carried through to completion by the same worker. A man would put much of himself into his work, would be absorbed in it, when he executed it all himself. The difficulties he had to overcome, the taste he wished to realise, kept his mind in alertness, and the result of his efforts filled him with joy.

These elements of interest, this excitation of the intelligence that the old craftsmen found, exists no more. The Machine Age, the division of labour, have transformed the worker in one simple manoeuvre: they have killed the joy of work. It is sad that in the factory, man coupled to the machine (which demands nothing of his mind) accomplishes a monotonous job from which he gets nothing but fatigue . . . It is the desire to escape the machine which has undoubtedly augmented the number of mediocre painters and sculptors . . . many of whom in other centuries would have been able joiners, potters or ironworkers, if such professions

offered the same attractions as in former epochs.

Whatever may be the importance of the secondary causes in the decay of our accomplishments, the principal one, in my opinion, is the absence of ideal. The most facile hand cannot be more than the servant of the mind, and the efforts to make our artisans into men like those of former times, will fail, I fear. Even when we manage to produce in the schools professionally skilled workers, knowing the technique of their craft, we shall do nothing for them as long as they possess no ideal to bring their tradition to life . . .

Painting is a job like the carpenter's and the smith's; it is subject to the same rules . . .

Ambroise Vollard, the famous art dealer, who did so much to promote the interests of the Impressionists in their early days, recorded many conversations he had with Renoir, as well as with other painters such as Degas and Cézanne. The following 'dialogues' with Renoir are taken from Vollard's volume, *Renoir, Sa Vie et Son Oeuvre*, published in Paris in 1918. Renoir, here, expresses his opinions on a variety of subjects, from eighteenth-century Spain—one of his favourite periods of art—to the Salon's rejection of Matisse's early works. Vollard: 'The Impressionist Theories'—these are literature 'throwing a grappling iron' at painting. But you cannot deny the benefit some paintings have got from the work of Chevreul on the solar spectrum. Have the Neo-Impressionists not applied some of these scientific gifts . . . ?
Renoir: The who . . . ?
Vollard: You know, the pictures with pure colours put side by side.
Renoir: Ah yes! The *petit point* school of painting. Mirbeau took me one day to a show of that . . . He went before me to see what the paintings represented. You have to be at least seven feet away. And I, who love to walk about a painting, to hold it in the hand! What is worse, how they have dark-ened! You remember Seurat's big picture of models in a studio? The one we saw together, painted in *petit point*, the last word in science. What a deplorable tone it has! Do you see the *Wedding Feast at Cana* being done in *petit point*? When Seurat makes proper use of colour like everyone else, on all those little bits of canvas, they are very well preserved.

The fact is that in painting, as in other arts, there is no single procedure small enough to be stated in a formula. Look, I have wanted to measure out the oil to be put in my colour once and for all. Well, I couldn't do it. I had to judge it afresh every time. I believe I knew a long time before the 'scientifics' that it is the opposition of yellow and blue which provokes violet shadows, but when you know that, you are still in ignorance of everything. There is much to painting which can't be explained and which is essential. You arrive before nature with theories, and nature throws them to the ground.

It is an obvious thing to say that El Greco is a very great painter, except perhaps in the matter of the studio light effects, the sameness of the hands, and the chic draperies . . . Because of that, and by my nature, I prefer Velasquez. What I love so much in this painter is the aristocracy that one always finds in the least detail, a simple ribbon . . . the small pink ribbon of the Infanta Marguerita . . . all the art of painting is contained in it! And not a shadow of sentimentality.

I know that Velasquez' critics reproach him for painting with facility. What better proof to the contrary that Velasquez was a painter in command of his craft? Only those who know their craft can give the impression that all is done at a blow. But reason tells us how much searching there is in this painting done, apparently, so easily. And how well he knows how to use black. The more I go on, the more I love black . . .

I don't know how to choose between all these marvellous

things! The execution of these pictures is divine! With a rub in of black and white Velasquez manages to give us thick and heavy embroideries. And *The Spinners*! I don't know anything more lovely . . . Wasn't it Charles Blanc who said that Velasquez was too much down to earth? Always this need to look for the thought behind a painting! For myself, I prefer simply to enjoy a masterpiece. Professors discover faults in the masters, but faults can be necessities. In the *St Michael* of Raphael there is a thigh a kilometre long. It would be less good if it were not. And Michelangelo himself, the anatomist par excellence. The other day I was afraid that the breasts of my 'Venus' were too far apart, and then I came upon a photograph of the 'Aurora' in the Medici Tomb, and I could see that Michelangelo's work was none the worse for having the breasts even further apart. And look at the *Wedding Feast at Cana* . . . if the table were in true perspective with the people at the back, it would appear empty. It is full, because the people at the back and the front of the picture are the same size. Moreover, the floor does not go according to the rules; perhaps that is why it goes so well.

One more thing about Velasquez which delights me—the paintings breathe the joy of the artist in painting them.

It isn't enough for a painter to be skilful; one should be able to see that he loves to caress his canvas. That is what Van Gogh lacks. What a painter! . . . but his canvas is not stroked lovingly with the brush. And there is this slightly exotic side to him . . .

The *Royal Family* of Goya, which by itself is worth the voyage to Madrid—when you are in front of it, you only notice that the king looks like a pig merchant, that the queen seems to have escaped from a potman to say no more. The diamonds she is covered with! Nobody has done diamonds like Goya. And the little satin shoes he paints!

The harm that the Salons can do is unbelievable. Did you hear that woman the other day? 'My son has captured the style of the Salon d'Automne.'

Wasn't it you, Vollard, who told me that the Salon d'Automne has just rejected Matisse? It is curious how repelled these men are by finding the qualities of paint in a painting. The one who really exasperates them is the Douanier Rousseau! This *Scene of Prehistoric Times* with a hunter right in the middle, dressed *à la Belle Jardinière* and carrying a rifle . . . But to begin with, is it possible not to enjoy a canvas where every colour is in place? Must one understand the subject? And what lovely tone, this little picture by Rousseau . . . I am certain that Ingres would not have hated the picture.

Nothing disconcerts so much as simplicity. I remember the indignation of Jules Dupré at one of our exhibitions:

'Today you paint as you like . . . You don't even prepare your canvases . . . Is this what the great and the strong did?' Dupré was alluding to the preparation with red which was then the thing. It was thought that this priming on the canvas gave 'sonority' to a painting, which in theory was certainly true; but the great and the strong of this period only succeeded with all their red lead in producing works which lacked sonority and which, in addition, cracked all over. Canvases like *The Angelus* (Jean-François Millet), how much time can one give it? Already the Duprés are running in their frames.

What an extraordinary period! These men who spent three-quarters of their time dreaming! It was necessary for the subject to crystallise in the mind before being put on canvas. One heard such things as this: 'The Master is overtaxing himself; for three days he has been dreaming in the forest!' . . . Apart from the few like Dupré, like Daubigny, and especially Millet who 'succeeded', what can one say of the quantity of poor devils who took seriously the myth of the

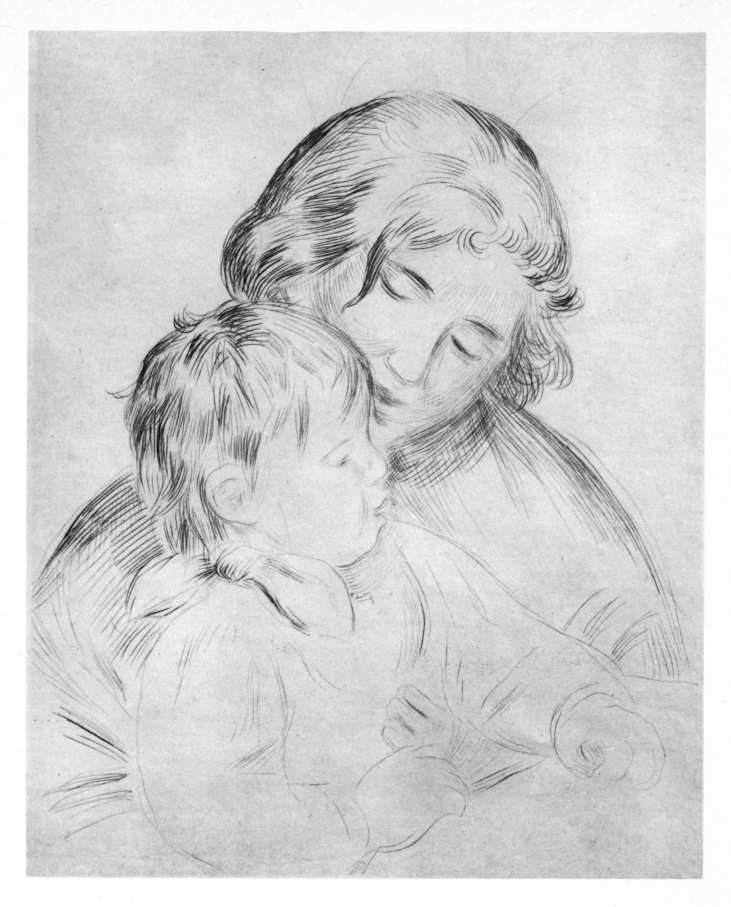

24

artist as a 'dreamer' and a 'thinker' and passed their time clutching their heads in their hands before a canvas forever uncovered? Imagine the scorn these men had for us who put colour on the canvas and, following the example of the Old Masters, sought to paint with happy tones works from which all 'literature' was sedulously banished!

These two recorded conversations with Renoir are from Albert André's biography of the painter, *Renoir*, Paris, 1923:

The palette of a painter signifies nothing; it is his eye which does everything. There are some colours which one squeezes out with more pleasure than others; one ends up by adopting them. I formerly used a chrome, which is a superb colour but which apparently plays evil tricks. I tried cadmium; I found great difficulties in using it, and it made my painting heavy. When I came to paint my 'Little Rubens', I tried painting with Naples yellow, which is a tame enough colour. It gave me all the brilliance I had been looking for.

But it is always the same story; such an effect depends on what I put around it.
Listen, I will let you in on my secret—tell no one. Yes, I am going to tell you where I found the secret of painting. It was in a tobacconist's. One day I was thinking about this blessed painting business while I was buying some cigars: the tobacconist showed me two boxes, asking:

'Colorado? Claro?'

'Colorado! Claro!' I cried, 'but that is what painting is; now I have it.' And I carried off both boxes.

7 *Mother and Child*. Colour etching. $9\frac{3}{4} \times 7\frac{7}{8}$ in. $(24.7 \times 19.9$ cm.). Victoria and Albert Museum, London

Comments on Renoir

The following is from Georges Rivière's review of the Group Exhibition of 1877, printed in *L'Impressioniste*, No. I, 6th April, 1877:

The exhibition at the Rue Peletier shows us living scenes which do not sadden the eye or the spirit; luminous landscapes, joyous or grandiose; never any of those lugubrious notes which make a black mark on the eye.

Starting with the works of M. Renoir and with his most important work, *Le Bal* (*Le Moulin de la Galette*)... In a garden flooded with light, scarcely shadowed by a few thin acacias, whose slender leaves tremble at the least wind, some young ladies with all the charm of their fifteen years, proud of their flimsy dresses, the material of which has cost so little and the style nothing, and some young men full of gaiety, compose the happy crowd whose hullabaloo drowns the orchestra. The lost notes of a quadrille come through from time to time to restore the dancer's measure. Noise, laughter, movement, sun, in an atmosphere of youth, such is *Le Bal* of M. Renoir. It is essentially a Parisian work. The girls are the very same who elbow us every day and whose babble fills Paris at certain hours. A smile and a flick of the wrist is enough to be pretty; M. Renoir proves it. See the grace with which a pretty girl reclines on a bench! And that young philosopher, sitting astride his chair and smoking a pipe, what a profound contempt he must have for the fluttering of the dancers who seem to disdain the sun in the energy of a polka.

M. Renoir has good reason to be proud of his *Bal*; never has he been more inspired. It is a page of history, a rigorously precise and precious monument to Parisian life. No one before him has dreamt of noting the existence of everyday life on such a grand scale of canvas. It is a historic picture. M. Renoir and his friends have discovered that history painting is not the illustration, more or less, of droll tales from the past:

they have opened a way where others will certainly follow. Of what importance to us are the operetta kings rigged out in blue or yellow robes, carrying a sceptre in the hand and a crown on the head? When, for the hundredth time, we are shown St Louis dealing out justice under an oak, are we much better for it? What documents will these artists who deliver us from such lucubrations bequeath to future centuries for the history of our times!

From an article by Arsène Houssaye, printed in *L'Artiste*, 1870:

The two true masters of this school, who instead of talking about Art for Art's sake, talk about Nature for Nature's sake, are MM. Monet (do not confuse him with Manet) and Renoir: they are, like Courbet of Ornans, two true masters with the brutal frankness of their brush. I am told that the jury rejected M. Monet, but had the good sense to accept M. Renoir...

Gleyre, his master, must have been surprised to have shaped such a prodigious child who laughs in his own way. But Gleyre is too great a painter not to recognise Art, whatever form it takes.

Remember, then, the name of M. Renoir and the name of M. Monet. I have in my gallery the *Woman in the Green Dress* by Monet and a first *Bather* by Renoir which I shall give one day to the Musée du Luxembourg, when the Musée du Luxembourg opens its doors to all attitudes of the brush.

Emile Zola was one of the first to champion the Impressionists. The following extract is from an article by him which appeared in *Le Voltaire*, 1880:

Certainly... the exhibitions of the Impressionists occupied all Paris for a moment. Their praises were sung, they were

swamped with laughter and derision, but the visitors came in crowds. Unhappily, all this was only noise, the noise of Paris borne away on the wind.

M. Renoir was the first to understand that commissions would never arrive in this way, and, as he had to live, he started to send once more to the official Salon, and this has resulted in his treatment as a renegade. I am for independence in all things: yet I must say that the conduct of M. Renoir seems to me to be perfectly reasonable. One must be aware of the admirable opportunities for publicity that the official Salon offers to young artists; our habits being what they are, it is only there that they can triumph seriously. Certainly, they must guard their independence in their works, and watch that nothing of their temperament is attenuated; then, they should give battle in the open.

Excerpts from a letter to Bergerat from Renoir's brother Edmond, printed in *La Vie Moderne*, June 1879. It contains an account of Renoir's debut as an artist, and some intimate descriptions of his attitude to his work.

My dear Bergerat,
. . . At the age of fifteen my brother was obliged to take up a job . . . from what he did with sticks of charcoal on the walls, it was decided that he possessed a bent for the artistic profession. My parents therefore placed him with a porcelain painter . . . The young apprentice applied himself diligently to his job: the day over, armed with a portfolio taller than himself, he would go off to the free drawing classes. This lasted two or three years.

He progressed rapidly: after a few months' apprenticeship, he was entrusted with pieces usually reserved for the mature craftsmen, a fact which was made something of a joke—they called him, laughingly, 'Monsieur Rubens'—and he used to cry at being made fun of. However, among these craftsmen

there was a good-natured old fellow whose passion it was to paint in oils at home: glad, perhaps, to have a pupil, he gave the young man some of his canvases and colours. After some time, my brother tried painting a picture on his own.

The apprentice stuck at his task, and, one Sunday, the visit of the first instructor of the painter of *Lise* and *Le Moulin de la Galette* was announced. I remember it as if it were yesterday. I was still a boy, but I could understand that important matters were afoot: an easel carrying the famous canvas was placed in the middle of the largest room of our modest lodgings in the Rue d'Argenteuil. Everybody was impatient and excited. I had been brushed up and told to behave. It was a solemn moment. The 'master' arrived . . . at a signal I placed a chair before the easel; he sat down and began to inspect the work. It was (I can see it yet) an *Eve*; behind her a serpent entwined itself round the branches of an oak, coming forward with snarling jaws as if to hypnotise her.

The examination lasted a good quarter of an hour, after which, without any other comments, the poor dear fellow turned towards my parents and said simply, 'You must allow your son to paint: in our profession he will get at the most twelve or fifteen francs a day. I predict for him a brilliant career in the arts—see what you can do about it!'

Supper that night in the Rue d'Argenteuil was a sad one: the joy occasioned by success disappeared before the terrible prospect of letting him leave the work where his livelihood was assured, for the world of art, which could lead him straight to misery. At last, our parents resigned themselves, and the École des Beaux-Arts had one student the more.

Auguste entered the studio of Gleyre, studied anatomy, passed the courses of perspective and sketching—like everyone.

How then, a student of Gleyre, has he become what he is? It was like this: at this time, far more than now, the painting

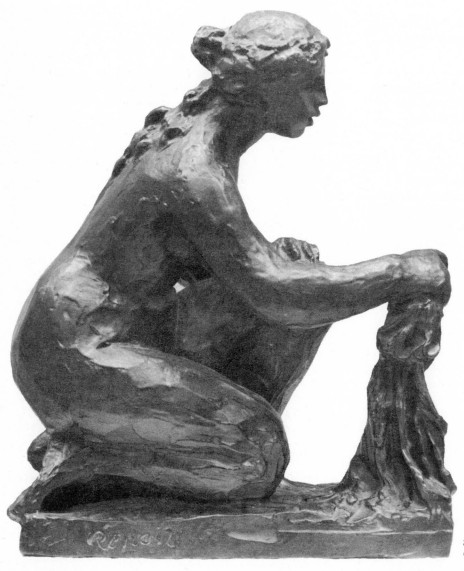

8 *La Laveuse*. Bronze. Height: 13¾ in. (35 cm.).
Courtauld Institute Galleries, London

students went out in parties to settle down in the forest of Fontainebleau. They had no studios like today; luxury was unknown. The inns of Chailly, Barbizon or Marlotte received them, big or small, and off they would go with knapsacks to work out of doors. It was there my brother met Courbet, the idol of the young painters, and Diaz, who held their admiration to an even greater degree. Diaz gave him the best lesson which he has perhaps ever received. It was Diaz who said to him, 'No painter with any self-respect will touch his brush unless he has a model before his eyes.'

This 'axiom' remained profoundly engraved in the mind of the young student. He said to himself that flesh and blood models cost too much and that he could find what he wanted in much better conditions, the forest being close enough to let him study at his leisure. He stayed there summer and winter throughout these years. It was by living in the open air that he became an open-air painter. The four cold walls of the studio did not press in on him; the uniform brown and grey tones of the walls did not dull his eye. Also the atmosphere and surroundings had an enormous influence upon him; having no memory of the kind of servitude to which artists so often bind themselves, he let himself be set in motion by his subject and above all by the character of the place he was in.

That is the particular quality of his work: he restated it everywhere and at all times, from *Lise*, painted in the open forest, to the *Portrait of Mme Charpentier and Her Children*, which was painted in her home without the furniture being moved from its normal daily place, and without anything being prepared to give more importance to one part of the picture than another.

When he painted the *Moulin de la Galette*, he settled down to it for six months, wedded to this whole world which so enchanted him, and for which models copying the poses would not serve: mixing himself in the whirlpool of this popular pleasure-gathering, he captured the hectic movement with dazzling vivacity.

When he painted a portrait? He begged his sitter to keep his ordinary clothes, to sit as he usually sat in his habitual position, so that nothing should look uncomfortable or prepared.

As well as this, his paintings had, apart from their artistic quality, all the innate charm of a picture faithful to modern life. He painted things we see every day; in these paintings, which will certainly remain among the most vital and harmonious of our time, we find our life recorded.

Likewise in *The Acrobats*, arrangement does not exist. With subtlety and bewildering spontaneity he had seized the fact of movement in the two children. Just so did they parade, wave, and smile in the circus ring; I need not use the grand words of Impressionism and Realism to say that here we can see real life with all its poetry and flavour...

It is in following my brother's whole output that one realises there is no 'method'. In none of these works, perhaps, can one find the same way of procedure; and yet they sustain themselves from beginning to end by aiming not at perfection of surface, but at a complete understanding of natural harmony.

I promised you a pen portrait: you will have seen him twenty times, up and down the boulevard, his head bowed, deep in thought. He is so preoccupied that he will go ten times to do something and forget every time to do it. In the street he hurries along, indoors he sits quite still for hours without speaking.

Where are his thoughts? With the picture he has done or the picture he is going to do... If you want to see his face light up and—miracle!—if you want to hear him singing some gay tune, don't look for him at table, or in the usual places of amusement, but try to surprise him at work...

Ed. Renoir

You must understand that adroitness is not indispensable. Didn't Renoir paint ravishing pictures with his left hand when he broke his right arm?

Camille Pissarro: *Letters to Lucien*

If Renoir draws as he does—for it is, after all, his weak point—it is not the fault of my having pleaded with him to take steps about it! I was then much smitten with David, and I still am; and he is someone whose line does not please one! If Renoir had listened to me and had united drawing and colour, who knows if he might not have become a second David, like my distinguished friend, the Lecomte de Nuoy. But when I said to Renoir: 'You must force yourself to draw!' Do you know how he answered me?

'I am like a little cork thrown in the water and carried by the current. I let myself paint as it comes to me!'

The painter Laporte, quoted by Vollard in his volume *Renoir*, Paris, 1918

Degas (with a brusque gesture): You know what I think of painters who work on the highways. It is that were I the government, I would have a brigade of *Gendarmerie* to keep an eye on the men who do landscapes from nature . . .
Vollard: But Renoir, doesn't he paint in the open air?
Degas: Renoir! That's different: he can do anything he likes.

Vollard: *En Écoutant Degas*, Paris, 1919

I think very often of Renoir and that pure clean line of his. That's just how things and people look in this clean air.

Vincent van Gogh: *Letters to Theo*

I despise all living painters except Monet and Renoir, and I wish to achieve success through work.

Cézanne (Fragment of a letter, 1902)

I know of nothing I would sooner possess—and by our desire of possession we may measure our admiration—than one of Renoir's nudes. He has modelled whole bodies of women in the light, and the light is not only on the surface, apparently it is under the surface. Some of his portraits of children are the most beautiful I know—they are white and flower-like, and therefore very unlike the stunted, leering little monkeys which Sir Joshua Reynolds has persuaded us to accept as representative of tall and beautiful English children. Renoir's life supplies me with an instructive anecdote: but for you to approve of the anecdote you must know something of his early days. So I will tell you that he began life as a porcelain painter—I have seen flowered vases painted by him and pictures of flowers painted exactly as a porcelain painter would paint them. It was not till the 'sixties that he began to paint portraits. I think that it was at the end of the sixties that he painted the celebrated picture of the woman looking into the canary cage—a wonderful picture, but very unlike the Renoir of the nudes that I hunger to possess. Is it not strange that an art so strangely personal as Renoir's should have been developed by degrees? Manet was Manet as soon as he left Couture's studio—even before he went there. Degas was always Degas; but there was no sign of the late Renoir even in the portrait of the lady looking into the canary cage. The beautiful nudes would never have been painted if he had not come to the Café de la Nouvelle Athènes. But do I admire the nudes as much as I say I do? Renoir as a whole—is he the equal of Manet? Good heavens, no! And indeed at the bottom of my heart I always suspect Renoir's art of a certain vulgarity. If this be true, all the more strange that he, who was influenced by everybody, should have ended by influencing all the others. Manet's last pictures were certainly influenced by Renoir; Manet's last years were spent thinking of Renoir. Renoir was always in the Café de la Nouvelle Athènes, and I remember very well the

hatred with which he used to denounce the nineteenth century—
the century in which he used to say that there was no one
who could make a piece of furniture or a clock that was
beautiful and that was not a copy of an old one. It was about
that time that Durand-Ruel began to buy his pictures;
and one day, finding himself in easier circumstances, he
thought he would take what the newspapers call a well-
deserved—or is it a well-earned?—holiday. For some time
he was not sure whether he should lay in a stock of wine
and cigars and give dinner parties, or should furnish a flat
and fall in love. These are the outlets that life offers to the
successful painter, and it would have been as well for Renoir
if he had not been so virtuous: for he went instead to Ven-
ice to study Tintoretto, and when he returned to Paris he
entered a studio with a view to perfecting his drawing,
and in two years he had destroyed forever the beautiful art
which had taken twenty years to elaborate. The last time I
saw him was on the Butte Montmartre, a decaying *quartier*,
full of crumbling façades, pillars and abandoned gardens.
He was living in a small house at the end of one of these
gardens, interested far more in his rheumatism than in paint-
ing. I was talking to him of Aungtin, who believes that
the whole century has gone astray, that we must return to the
painting of our ancestors, to glazes; but Renoir showed little
interest—he only said *Chacun a sa marotte*, which means that
everyone has a bee in his bonnet. But why should this old
man take an interest in Aungtin's new aestheticism? Renoir
has said what he had to say, and when a man has done that,
the rest had better be silence.

George Moore: *Reminiscences of the Impressionist Painters*,
Maunsel, Dublin, 1906

It is not surprising that speculators in Renoir should have
been to the last unanimous in asserting that Renoir's latest

9 *Mother and Child.* Bronze: 21¼ in. (54 cm.). Tate Gallery, London

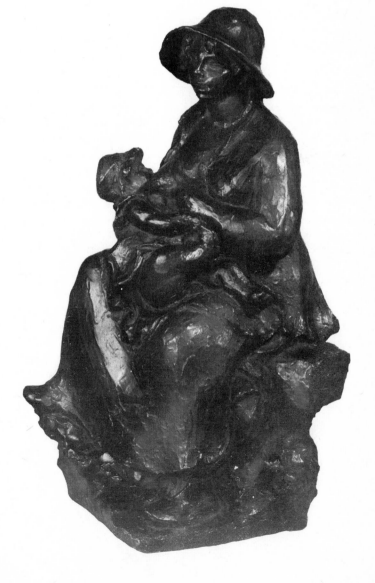

works were better than ever. That any critic should have been found innocent enough to echo this two-edged politeness has always astonished me. It may not be necessary to tell an old man, stricken with mortal malady, that his work can never again be what it was. He certainly knows this better than anyone else. The transparent flattery combines derision of his intelligence with obvious insult to his masterpieces ... one of the most brillant Renoirs in existence, a flower painting of roses and honeysuckle ... this canvas by Renoir brings sharply before us the gulf that separates the painter of genius from one of respectable achievement.

The flowers of Fantin are applied, rather than painted, on a mechanically scumbled background that creates with them no cubic space. The flowers are seen as painstaking items, the collocation of which may be said to have neither rhyme nor reason, since, in art, rhyme, and rhyme alone, is reason. Renoir at his best ... has all the qualities that constitute a great painter, pressed down and running over ... It would be so illogical to suppose that the greatest heirs of all the ages should not have over their predecessors the added advantage bestowed by the passage of time, and even power in using it, which we need not be surprised to find cumulative.

W. R. Sickert: *A Free House*, Macmillan, London, 1947

One of Renoir's sons wrote to M. Durand-Ruel on the death of his father:

My father had an attack of bronchial pneumonia which had lasted fifteen days. The last days of the previous month he seemed recovered and had taken up his work, when, suddenly, on the 1st December, he felt ill. The doctor diagnosed a congestion of the lung, much worse than that of the previous year. We did not expect such an outcome. The two last days he stayed in his room, but was not confined to bed all the time.

He kept saying: 'I am done for,' but without conviction, and he had said this often enough over the past three years. The constant attention irritated him a little and he kept scoffing at it.

On Tuesday, he lay down for seven hours after quietly smoking a cigarette.

He wanted to draw a vase, but no chalk could be found. At eight o'clock he fell suddenly into a light delirium. We were taken by surprise and passed from relative confidence to great apprehension. His delirium mounted. The doctor came. My father was restless until midnight, but he did not suffer at all ... At midnight he relaxed, and at two o'clock he quietly died.

Notes on the plates

(All the paintings here reproduced are oils on canvas)

Plate 1 *Portrait of Frédéric Bazille.* 1868. 41¾ × 29 in. (106 × 73.5 cm.). Musée du Louvre, Paris.

Bazille was a native of Montpellier who joined the *atelier* of Gleyre after giving up the idea of medicine as a career. A fellow student of Monet, Renoir and Sisley, he remained intimate with them throughout the 'sixties. Less fluent than the others, he was nevertheless a most gifted painter whose picture *Family Reunion* is one of the important works of the period. He was killed in the Franco-Prussian War. Renoir in this portrait shows himself not yet freed from the stylistic influence of Courbet: the rendering of Bazille's working clothes is in the direct language of the master, while the arrangement owes something to Manet. It is realism of a very different kind from Renoir's later 'sharp manner'; the distribution of light and shadow, in the *chiaroscuro* tradition, forms the basis of the composition as much as the linear forms. The painting, which once belonged to Manet, is a reminder of the solid basis on which Renoir nurtured his talent.

Plate 2 *Le Moulin de la Galette.* 1876. 30¾ × 45 in. (78 × 114.5 cm.). Musée du Louvre, Paris.

This is the painting, Renoir's masterpiece up to this date, of which Georges Rivière wrote with somewhat flowery enthusiasm in his review of the Group Exhibition of 1877 (see page 26). He painted it on the spot, as Monet had painted his giant figure groups in the forest of Fontainebleau ten years earlier. Each day his friends would help him to carry the canvas to the pleasure-garden and pose for him with the girls whom Renoir cajoled into joining them. While the forms lack, perhaps, the solidarity of his later period, the painting is a *tour-de-force* of Impressionist beliefs.

Plate 3 *The Swing.* 1876. 35¾ × 28 in. (90.5 × 71 cm.). Musée du Louvre, Paris.

Something of a companion-piece to *Le Moulin de la Galette*, this painting shares the same preoccupation with Impressionist light. The painter Caillebotte bought both pictures and bequeathed them to the Louvre.

Plate 4 *The Theatre Box.* 1874. 31½ × 25 in. (80 × 63.5 cm.). The Courtauld Institute Galleries, London.

The girl in the theatre box is saved from formality by the spontaneous rendering of her companion, raking the gallery with his opera glasses. There is something Rubensesque in the painting of this picture with the girl's dark eyes given their full value against the lightly restrained tones of the flesh. This was one of the qualities that Renoir in particular restored to painting (in this respect he is a true heir of Rubens and the Venetians); as in a Velasquez, he gives full value to the black of the dress material, instead of dissipating this 'queen of colours' by using it to describe heavy shadow. Impressionism has given him, in the flesh shadows, a pure pale blue which not even Rubens or Gainsborough would have quite dared to use.

Plate 5 *The Luncheon of the Boating Party.* 1881. 50¼ × 62 in. (128 × 172.5 cm.). Phillips Memorial Gallery, Washington.

This is, in a sense, Renoir's *Moulin* of five years later—a summing up of his achievements. It is more coherent than the earlier painting, although the governing composition is very much the same, with its diagonal movement from bottom left to top right of the picture, with the main weight of the figures held in the right-hand triangle and with the supporting verticals in the background. The spirit expressed is the same also, but it is more maturely realised. The girl sitting down on the left is his future wife.

Plate 6 *At the Grenouillère.* 1879. 28½×34½ in. (79×87.5 cm.). Musée du Louvre, Paris.
The tonal blending of the girl's dress and shoulders with the background in the search for the quality of light is Impressionism at its most convinced. If the forms seem a little thin, it is just this sort of danger which began to worry Renoir over the next ten years.

Plate 7 *Girl Reading.* 1876. 17¾×14½ in. (43×36.5 cm.). Musée du Louvre, Paris.

Plate 8 *Portrait of a Young Girl* (date unknown). 25¼×20¾ in. (64.5×53 cm.). Private Collection, Paris.
Renoir and Manet each found himself influenced by the other's painting at one time or another. Here is Renoir somewhat under the spell of his friend.

Plate 9 *The Kasbah of Algiers.* 1881. 28¾×35¾ in. (73×90.5 cm.). Musée du Louvre, Paris.
Renoir visited Algeria in 1881, when he began to travel extensively; until then he had not been able to afford it. In this view of the native quarter of Algiers he exercises his recurring interest in the crowd as a subject: perhaps the exotic setting made him for once illustrative rather than pictorial.

Plate 10 *Portrait of Claude Monet.* 1875. 33×23½ in. (73.5×59.5 cm.). Musée du Louvre, Paris.
Renoir made this portrait of his friend during their 'partnership' at Argenteuil.

Plate 11 *Girl with a Blue Ribbon.* 1880. 17¾×13¾ in. (45×35 cm.). Private Collection, Paris.
No one has painted children better than Renoir. He shares the quality that we see in Gainsborough's portraits of his daughter. Painters of this calibre can be infinitely sympathetic without being in the least sentimental.

Plate 12 *La Boulangère.* 1904. 21¼×25¾ in. (54×65 cm.). Private Collection, Paris.
This small canvas of Renoir's other servant-model whom he painted often is one of his finest nudes. The nude in an ideal landscape was still a credible and serious subject matter in the time of Poussin. Other fine painters have charmed us with it since, in various worlds of make-believe; perhaps only Renoir has really convinced us.

Plate 13 *Spring Landscape.* c. 1877. 14⅞×20¾ in. (38×53 cm.). Musée National des Beaux Arts, Algiers.
Here is text-book Impressionism, the complete dismissal of line: the exploration of the subject only emerges by courtesy of colour variations in the hooks and commas of the brush.

Plate 14 *The Umbrellas.* c. 1884. 71×45¼ in. (180×114.5 cm.). National Gallery, London. Lane Bequest.
This famous painting, the most 'important' Renoir in British collections, shows his classical preoccupations at this period in more than the tight outlines of the forms. The lack of design, of which the Impressionists used to be accused, was almost always design hidden more cunningly under the mask of reality. Here, geometry comes more to the surface; there is nothing arbitrary about the placing of the shapes in this picture. Renoir was in a mood of enthusiastic classical self-discipline; the umbrella shafts serve the same purpose as that of the lances in Uccello's *Rout of San Romano* and Velasquez' *Surrender at Breda* in building the picture. The tilt of the head of the girl carrying the basket is derived from the bottom left-hand corner, and the whole right-hand group is contained in a great arc. This is an occasion when Renoir allowed nature to pose for him a little.

Plate 15 *The Nymph at the Spring*. c. 1882. 26¼×48⅜ in. (66.5×124 cm.). National Gallery, London.
This painting has been dated 1871 by some historians, but it appears to be in a style of several years later.

Plate 16 *The First Outing*. c. 1875-8. 25½×19¾ in. (64.5×50 cm.). National Gallery, London.

Plate 17 *Mme Charpentier*. 1878. 18¾×15¼ in. (47.5×40 cm.). Musée du Louvre, Paris.
Through Mme Charpentier's salon Renoir enlarged the circle of his admirers and consequently the sale of his pictures. If he does not lose quality by flattering his sitter a little, it is because to please was part of his artistic nature—as it was Van Dyck's and Gainsborough's. Renoir recalled: 'She was not content simply to invite artists to her soirées. She gave her husband the idea of founding *La Vie Moderne* in order to defend the cause of Impressionism. We were to collaborate. We were to be paid out of the profits, in other words, we would not touch a penny. But worst of all, we were provided, for drawing on, a paper which had to be scraped with a knife to obtain white; I have never been able to use it. The editor of *La Vie Moderne* was Bergerat. When Charpentier later gave up the magazine, my younger brother Edmond took on the editorship, but the journal was on its last legs, and it soon collapsed.'

Plate 18 *The Parisian girl*. 1874. 63×41½ in. (160×105.5 cm.). National Museum of Wales, Cardiff.

Plate 19 *The Guitarist*. 1897. 31⅞×25½ in. (81×65 cm.). Musée des Beaux Arts, Lyons.
Among the Impressionists only Degas was hailed in his own time as a master draughtsman. In the face of a work such as *The Guitarist* it is difficult for us to realise that Renoir

was able to tell Vollard that only once in his life had he been complimented on his drawing.

Plate 20 *Julie Manet with a Cat*. 1887. 25½×21¼ in. (64.5×53.5 cm.). Rouart Collection, Paris.
There is no lack of charm in this portrait painted in Renoir's 'sharp manner'. He used to say that the Old Masters managed very well with a few earth colours, and he seems to have used little more himself here. The design of the cat held in the arms is in itself a masterpiece of subtle simplicity; more masterly is Renoir's achievement in preventing such an inviting piece of the picture from distracting our attention from the head.

Plate 21 *The Daughters of Catulle-Mendès*. 1888. 64¼×51 in. (163×129.5 cm.). Private Collection, Paris.
Renoir painted several 'piano' pictures at this time, of which this and plate 23 are fine examples.

Plate 22 *Jean and Geneviève Caillebotte*. 1895. 25½×31¾ in. (65×81 cm.). Private Collection, Paris.
In spite of the apparent softness of Renoir's forms, they are controlled by firm design. The relationship of the books in this painting is as beautifully observed and resolved as that of the children's heads. The father of these children, Gustave Caillebotte, was a wealthy boat-builder and engineer. A spare-time painter, he met Monet and Renoir at Argenteuil, and at once fell under the spell of their art. He bought their pictures not only to help their desperate situation but because he admired them. He became a practising member of the Group, organising some of their later exhibitions and building up a fine collection of their paintings. These he bequeathed to the State, and when he died in 1894 there followed a long tussle between Renoir, the executor, and the embarrassed government, reluctant to accept them. When

a portion of the bequest was finally accepted and hung in the Luxembourg in 1897 there was an outcry from the Salon which is noted by Pissarro in a letter to his son Lucien: 'I'm sending you some newspapers. *L'Eclair* publishes an interview with Gérôme (the Institut has protested to the Minister of Fine Arts), he takes Renoir to task and says he should not be confused with Renouard, for the latter can draw, and has talent! The limit!'

Plate 23 *At the Piano.* 1892. 44×33¾ in. (112×86 cm.). Lehman Collection, New York.
Renoir painted two versions of this picture. There is a wonderful harmony between moving and static forms, which invite the spectator to delight in the bric-à-brac of a nineteenth-century drawing room. Things which Renoir considered ugly in themselves are not out for aesthetic reasons: they are made beautiful, like the iron railway bridges over the Seine, by the pictorial excitement with which he has put them down. Even the tired portrait device of the draped curtain in the background is given a new lease of life.

Plate 24 *Young Bather.* 1892. 31¾×25½ in. (81×65 cm.). Lehman Collection, New York.
Renoir's fascination for the tints of flesh never led him astray into the pitfalls of imitative colour. The girl's skin is rendered by an iridescent alternation of warm and cool values, an abstract and invented equivalent for nature which is picked up in the green, violet and orange accents of the background. 'Painting need not smell of the model,' he said, 'but it must have the scent of life.'

Plate 25 *Woman Combing Her Hair.* c. 1910. 21¾×18 in. (55 ×46 cm.). Musée du Louvre, Paris.
A monumental and classic Renoir. With a daring simplicity of detail he has used a sublime sense of interval to give

strength to a conception which in lesser hands would become woolly.

Plate 26 *Landscape at Cagnes.* c. 1902. 19⅝×25½ in. (50× 65 cm.). Private Collection, Paris.
A view of the countryside in which Renoir lived almost entirely during the last fifteen years of his life. Very different from the landscapes of Argenteuil, these later scenes, like *Sailing boats at Cagnes* (plate 28) and another Cagnes painting (plate 30) look forward to Bonnard, upon whom this period of Renoir's work had a great influence.

Plate 27 *Nude in Sunlight.* c. 1875-6. 31½×25½ in. (80× 61 cm.). Musée du Louvre, Paris.
As with the girl in *At the Grenouillère* (plate 6), Renoir uses the plein air nude to demostrate the virtues of Impressionism. The form, in a classical sense, is certainly suggested but the girl's main pictorial function is to allow the chance effects of sunlight and shadow to be projected on to her body.

Plate 28 *Sailing Boats at Cagnes.* c. 1895. 18×21½ in. (46× 55 cm.). Private Collection, Geneva.
See note to plate 26.

Plate 29 *Coco.* c. 1906. 13½×13½ in. (34×34 cm.). Lopez Collection, Algiers.
One of many portraits of Renoir's youngest son, Claude, born in 1901.

Plate 30 *Landscape at Cagnes.* c. 1905. 21⅝×18⅛ in. (55× 46 cm.). Lopez Collection, Algiers.
See note to plate 26.

Plate 31 *Portrait of Gabrielle.* c. 1890. 9×8 in. (22.5×20 cm.). Sir Kenneth Clark Collection, London.

As Renoir grew older, and his colour—which had never been imitative—withdrew more and more into his own world of original invention, so his drawing followed it, rising to the formalism of Titian and the Venetians whom he revered. But this only seemed to heighten his gift for expressing humanity, and this small portrait of Gabrielle is the essence of the young girl who became an intimate of the household, helping Mme Renoir when she was not posing for the painter, washing his brushes, and acting as a barrier between the famous man and the importunate pilgrims who, in later years, came to the house at Cagnes.

Plate 32 *Two Girls Reading in a Garden*. c. 1890. 18¾ × 21⅞ in. (46 × 55 cm.). Private Collection, Paris.
Renoir used this theme as a subject several times at this period.

Plate 33 *Still Life*. c. 1910. (Size unknown). Lopez Collection, Algiers.
Renoir painted constantly: plates of fruit and bowls of flowers were left about the house by Mme Renoir to catch his eye. Like the Cagnes landscapes, such still-life paintings as this helped to form the style of Bonnard.

Plate 34 *Young Girl Combing Her Hair*. 1894. 21¼ × 18 in. (53 × 44 cm.). Lehman Collection, New York.

Plate 35 *Cradle Rock, Guernsey*. 1883. 11⅜ × 21⅜ in. (29 × 54.5 cm.). Tate Gallery, London.
In a letter to Durand-Ruel written from Guernsey on 27th September 1883, Renoir said: 'I am here on a charming beach completely different from our Norman beaches . . . Here, people bathe among the rocks which serve as changing places, as there is nothing else; nothing more attractive than this collection of men and women gathered on the rocks.

It seems more like a landscape by Watteau than something real.'

Plate 36 *Portrait of Ambroise Vollard*. 1908. 32 × 25¼ in. (81 × 64 cm.). The Courtauld Institute Galleries, London.
This was the first painting Renoir made of Vollard, the art dealer and recorder of Impressionist conversation. Renoir has seen him in professional character, examining a statuette by Maillol. He painted Vollard again in 1917, dressing him up in the character of a bull-fighter.

Plate 37 *Portrait of Richard Wagner*. 1893. 15¾ × 12¼ in. (40 × 31 cm.). Musée de l'Opéra, Paris.
Since 1865, when Bazille had infected him with his enthusiasm for Wagner, Renoir had admired the work of the composer, whom he met in Italy. In this quick portrait he has not missed the note of self-centred impatience in Wagner's expression.

Plate 38 *Figures in a Garden* (date unknown). 18 × 21¾ in. (46 × 55 cm.). Ashmolean Museum, Oxford.

Plate 39 *Nude With a Straw Hat*. c. 1909. 21¾ × 18 in. (55 × 46 cm.). Private Collection, Paris.
By the late 1900s Renoir's nudes were taking on a primitive quality which came not so much from the rough execution forced on him by arthritic hands as from the projection of the forms towards the picture surface. With its monumental forms and restful pose, this painting has something of the Pompeiian frescoes, which he admired.

Plate 40 *Portrait of Madame Edwards*. 1904. 36¼ × 28¾ in. (92 × 73 cm.). National Gallery, London.
This is another fine example of Renoir's commissioned portraiture. The experience gained since the portrait of

Madame Charpentier (plate 17) has lent the portrayal of Madame Edwards a confident informality of pose without any loss of pictorial design.

Plate 41 *Woman Tying her Shoelace*. c. 1916. 19¾ × 22½ in. (48×57 cm.). The Courtauld Institute Galleries, London.
In his late painting Renoir came more and more to use red as a point of departure for his colour arrangements and often for the purposes of a visionary conception of life, far removed from nature. But, as in this painting, he often returned to simple domestic events for his subject matter.

Plate 42 *Nude* (date unknown). 13¼ × 16 in. (34×41 cm.). Ashmolean Museum, Oxford.
During his lifetime, and particularly in later years, Renoir painted a vast number of such small studies. Sometimes figures, fruit, flowers and landscapes appear, dotted about on one canvas. The sheer volume of his work alone, like Rembrandt's, shows how little leisure time he can ever have allowed himself.

Plate 43 *The Dairy Woman*. 1913-14. 15¼ × 13 in. (39×32 cm.). Museum of Fine Arts, Grenoble.

Plate 44 *Girl Reading*. 1893. (Size unknown). Lopez Collection, Algiers.

Plate 45 *Young Woman Dressing Her Hair*. 1901. 19½ × 17 in. (49.5×44 cm.). Private Collection, Paris.
Renoir excelled in his ability to preserve the immediacy and authenticity of an event with a sense of formalised design. The gesture of the girl fixing her hairpin in this picture is entirely convincing, yet the pictorial relationships of volume and interval are akin to those of a Roman fresco.

Plate 46 *Young Girl with a Fan*. c. 1910. 27⅞ × 18¾ in. (71 × 47.5 cm.). Cummings Collection, Chicago.

Plate 47 *Woman in an Armchair*. c. 1915. (Size unknown). Private Collection, Algiers.

Plate 48 *The Nymphs*. c. 1918. 43¼ × 63 in. (110 × 160 cm.). Musée du Louvre, Paris.
In this fine canvas, perhaps the most famous of his late *Baigneuses*, Renoir combined an intensely personal and original vision with an acknowledgment to Titian and the great Venetian tradition.

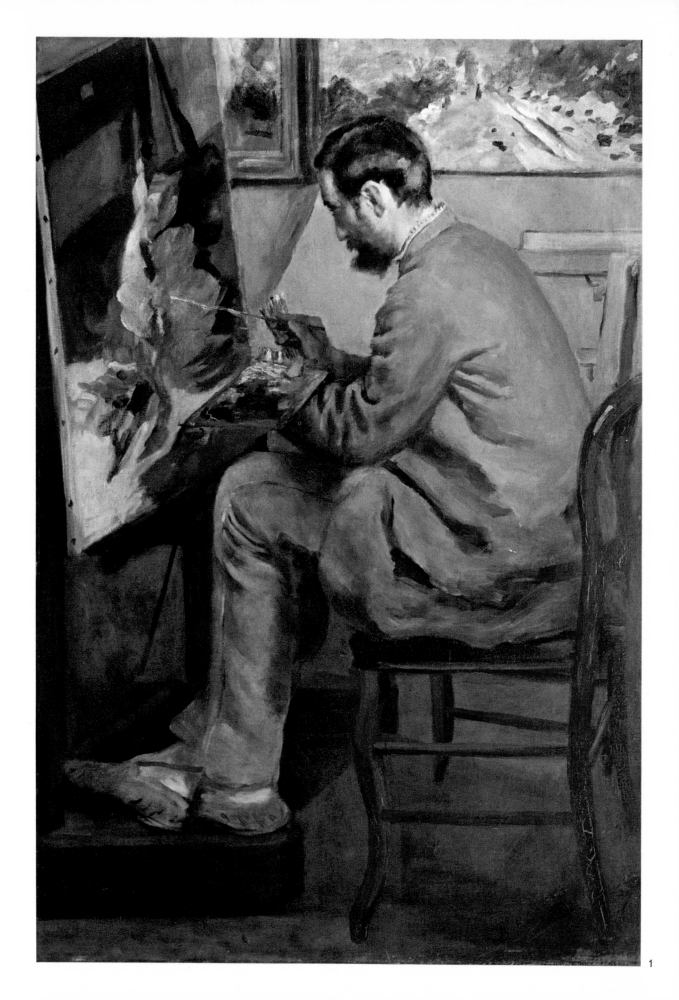

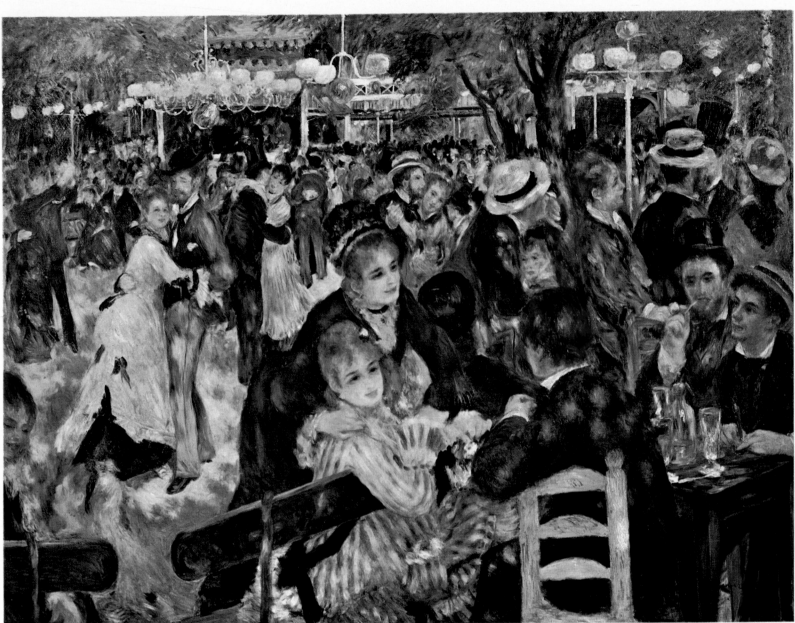

2

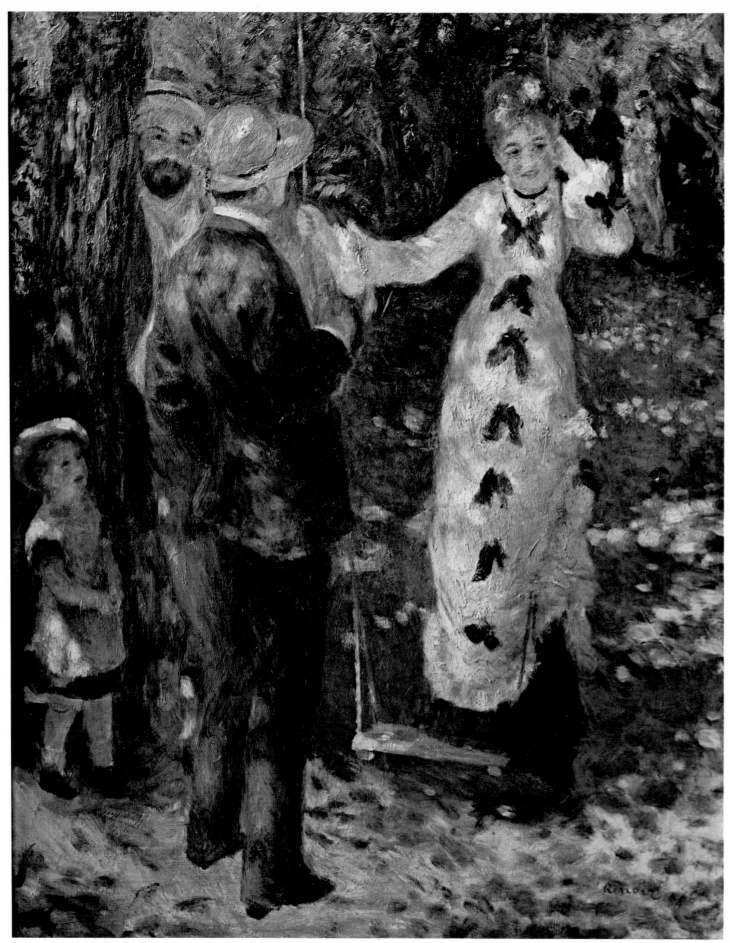

3

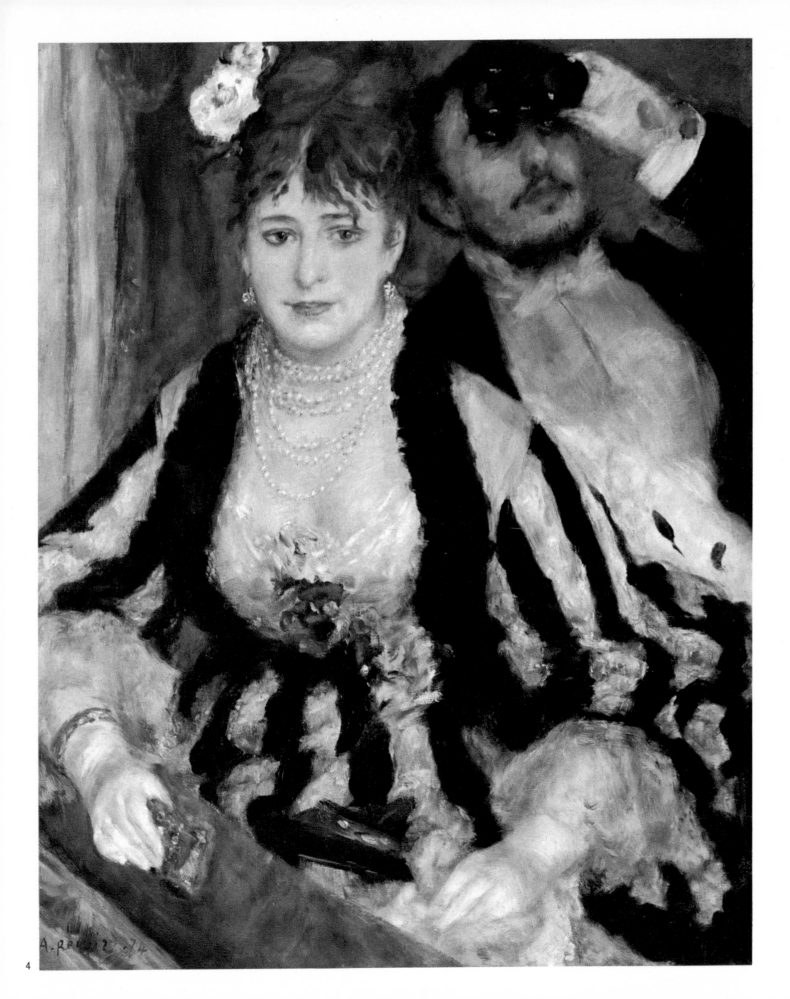

4

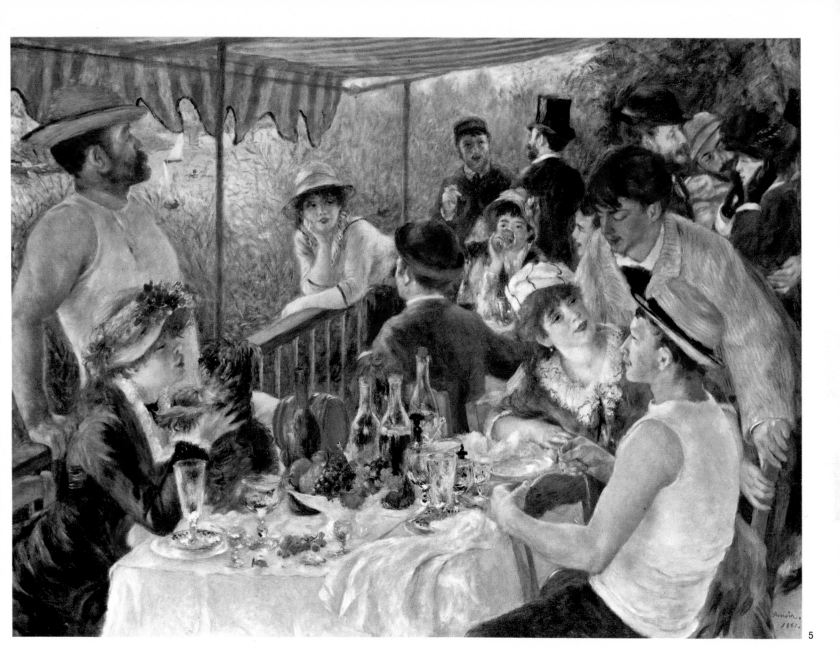

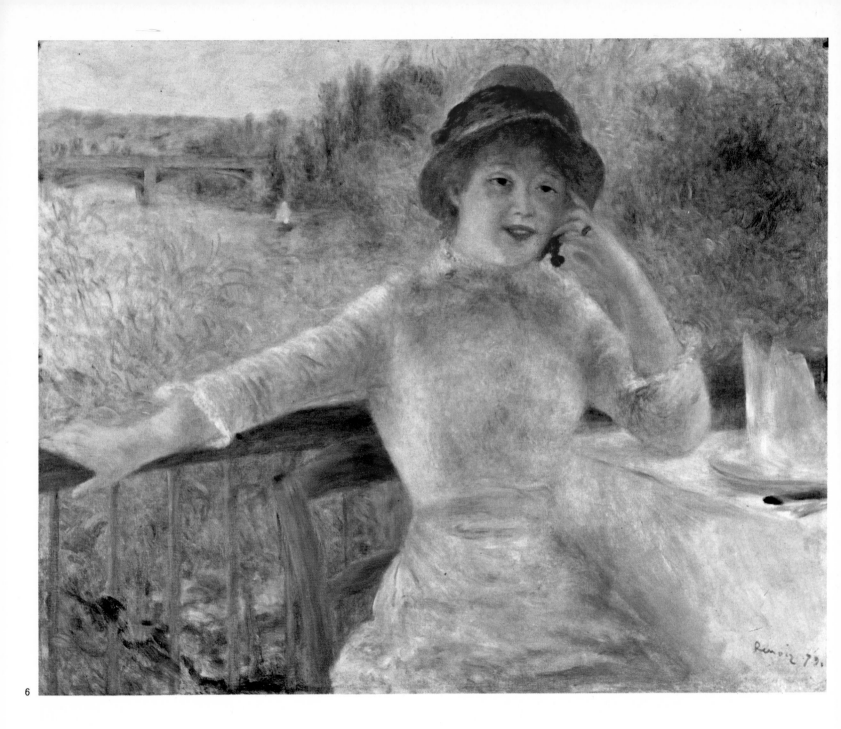

6

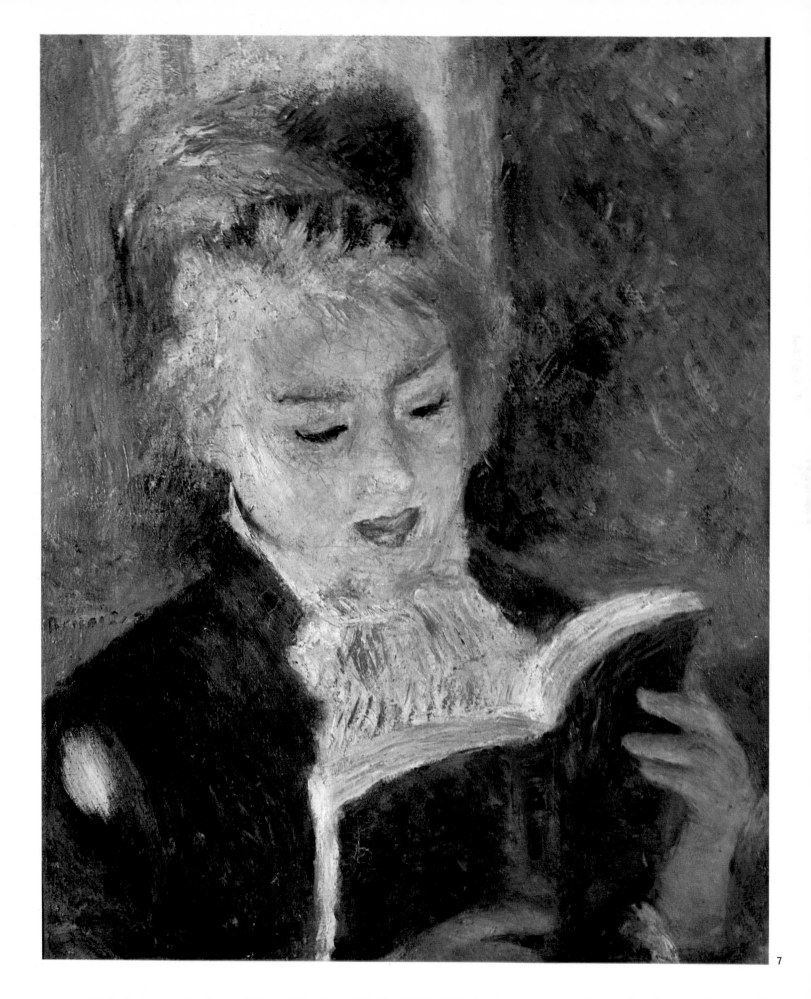

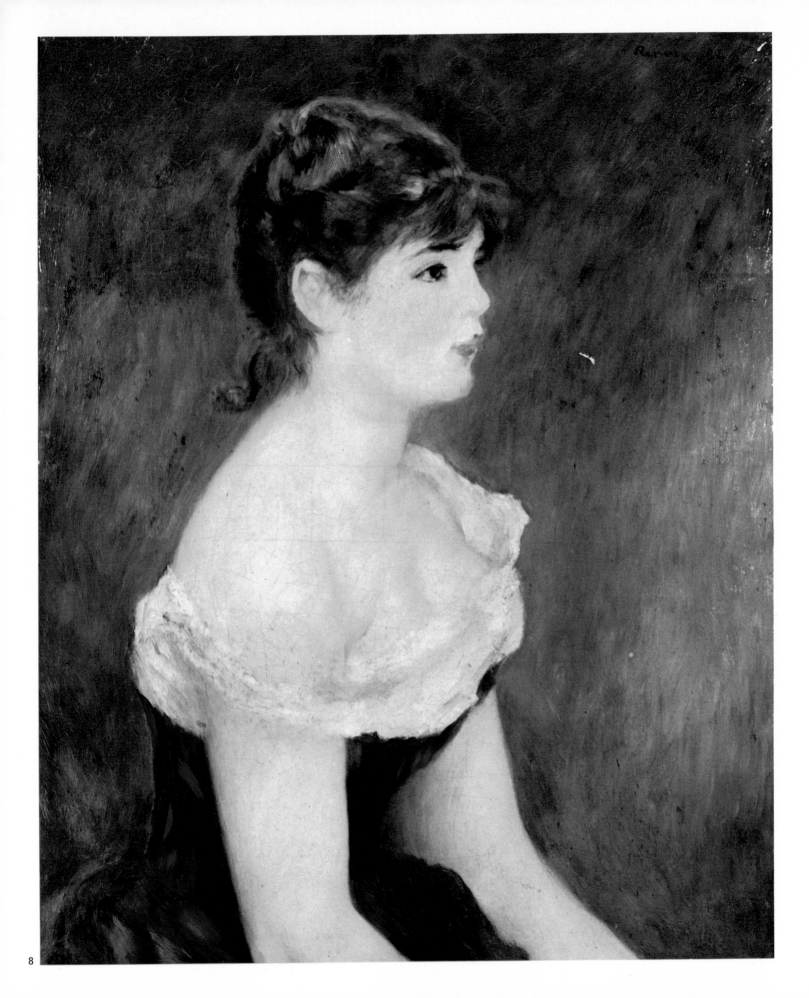

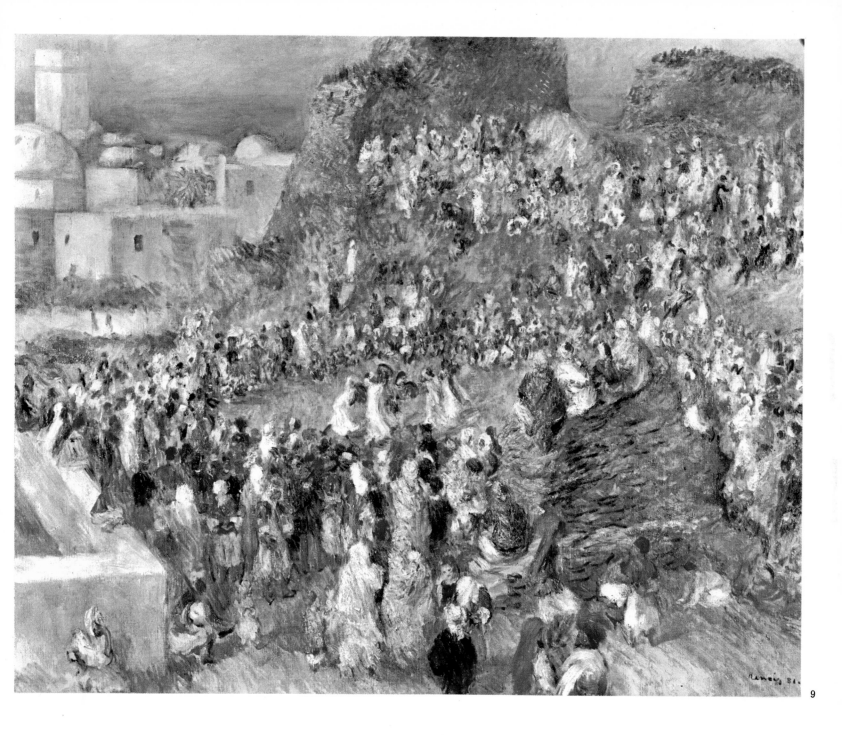

9

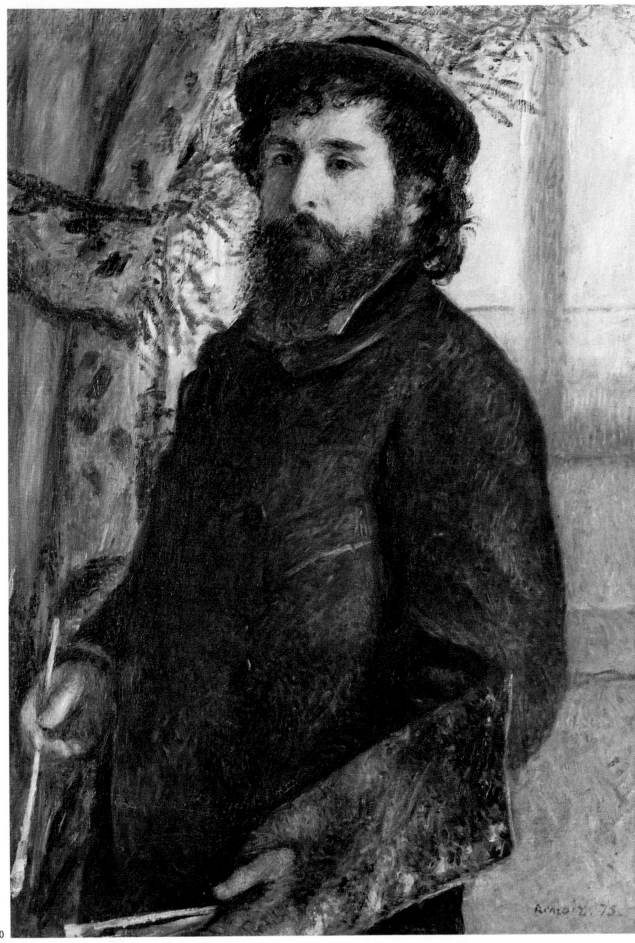

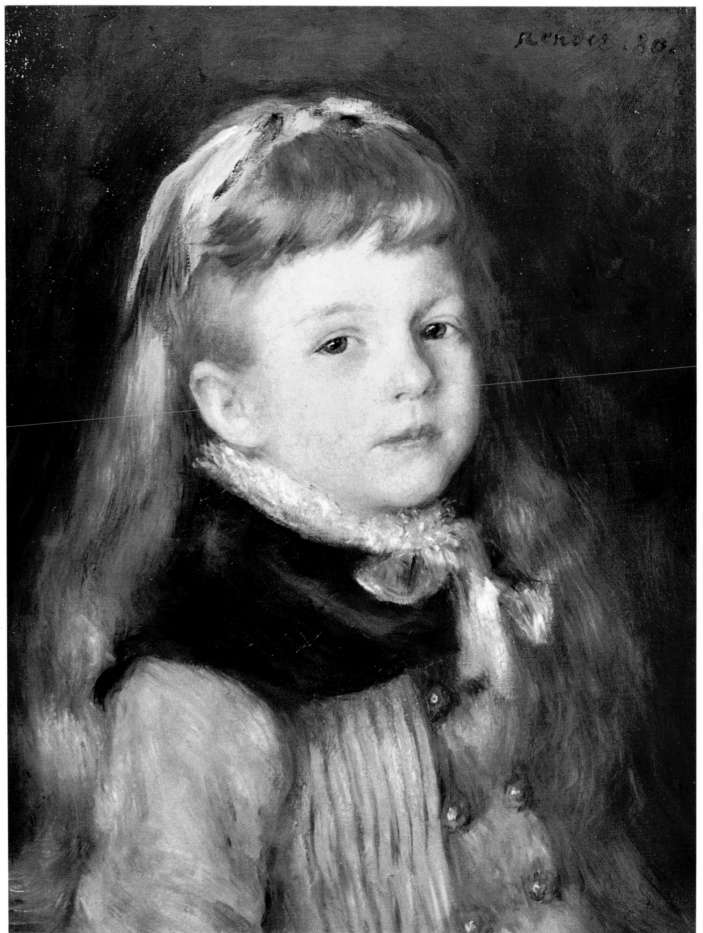

11

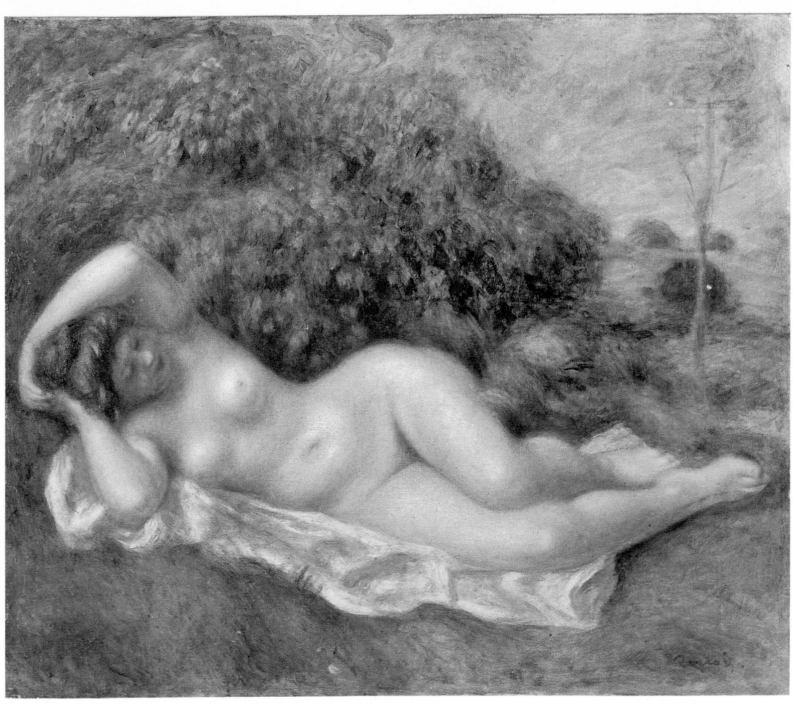

12

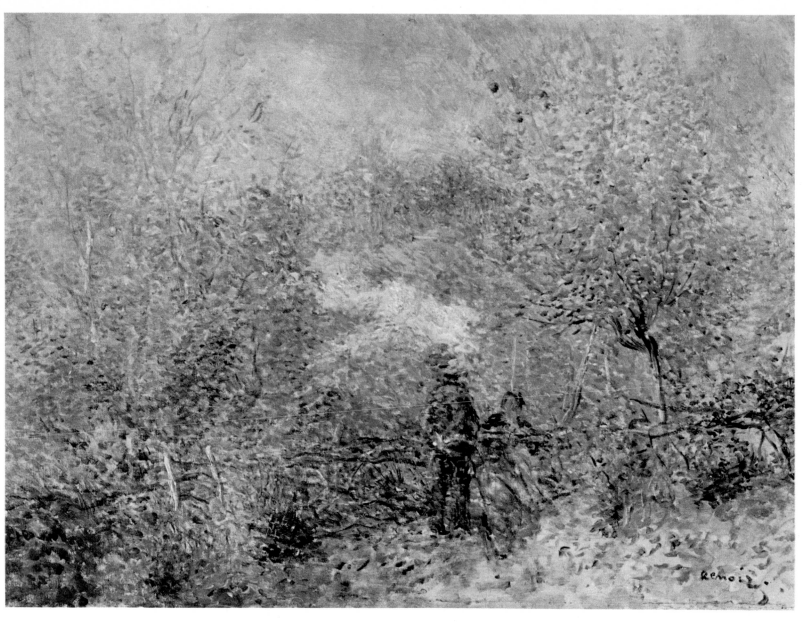

13

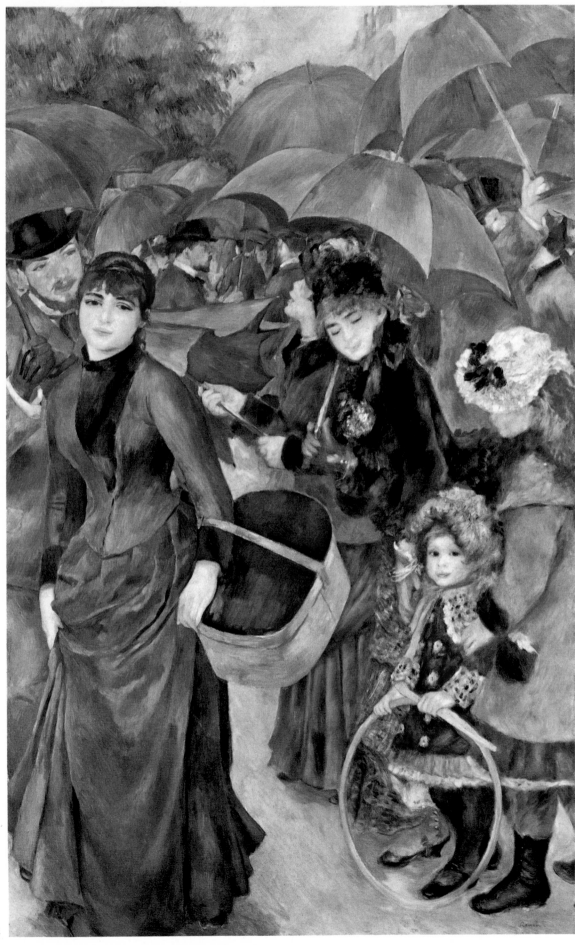

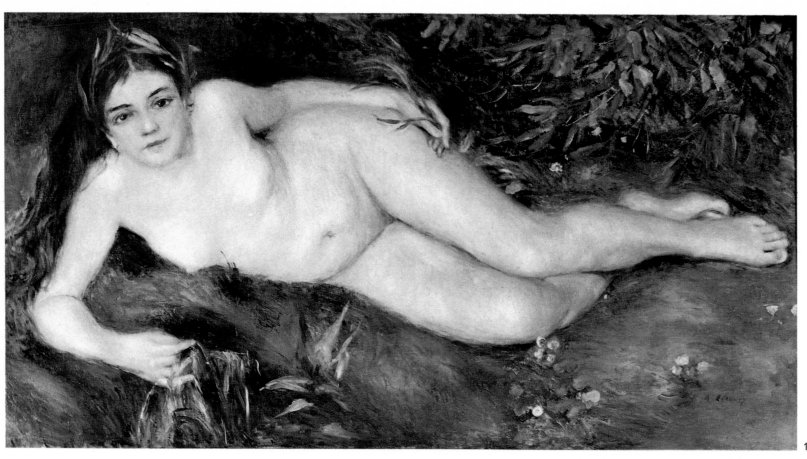

15

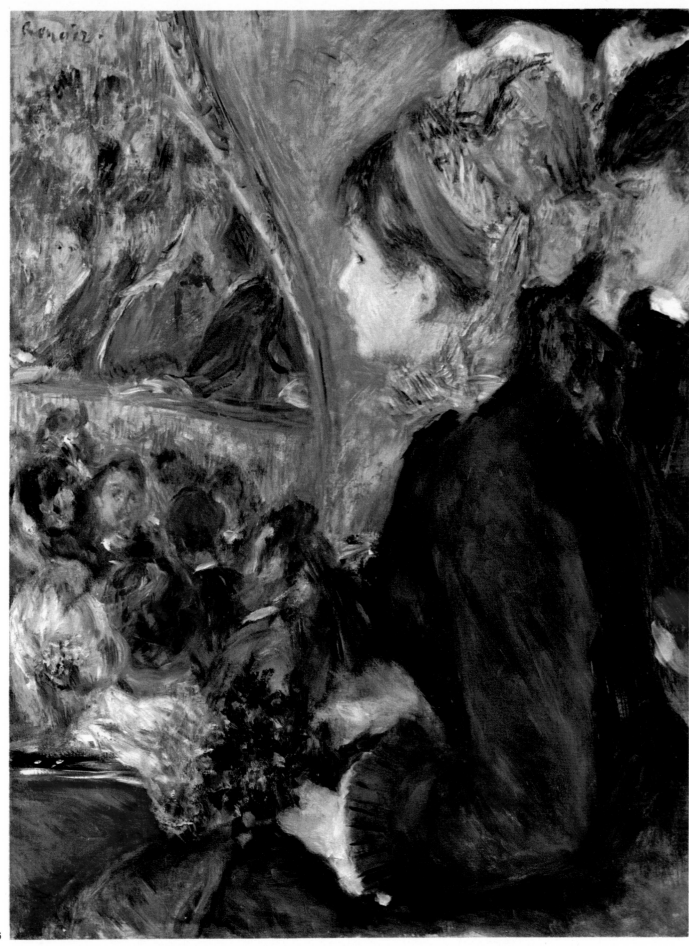

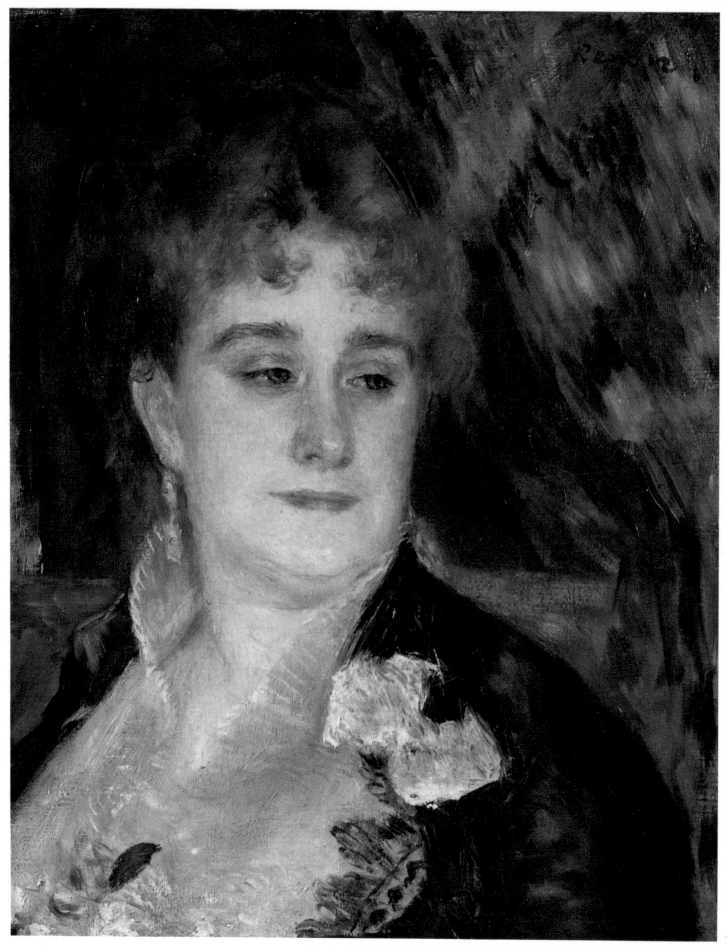

17

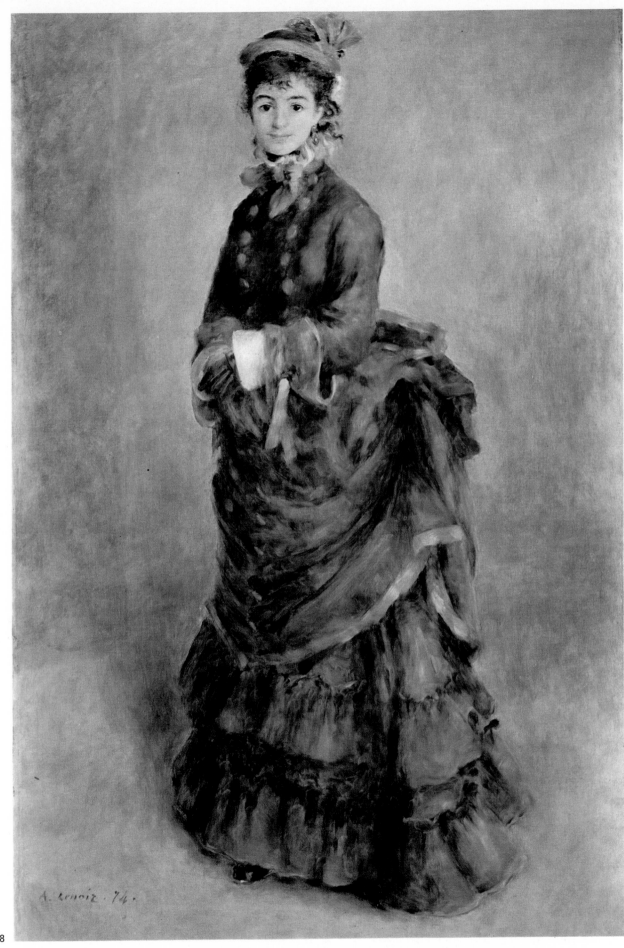

18

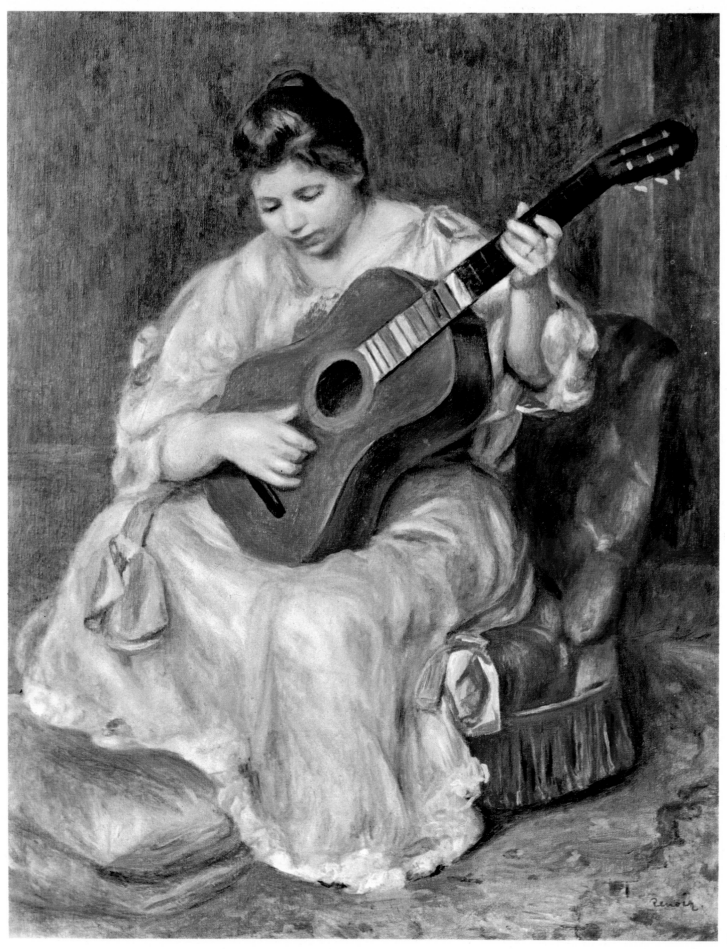

19

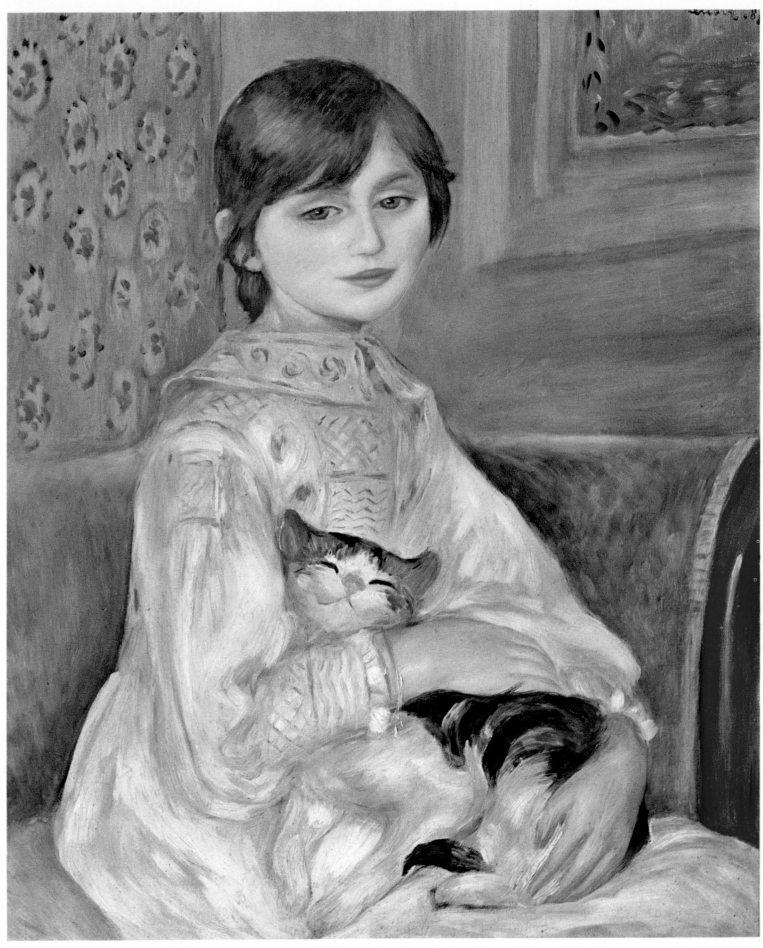

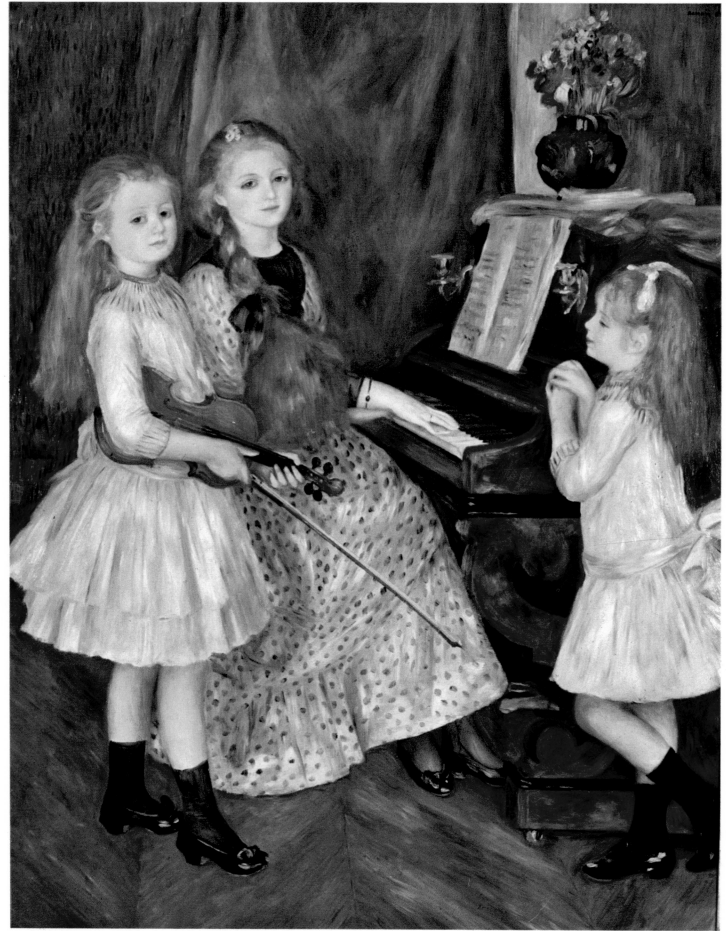

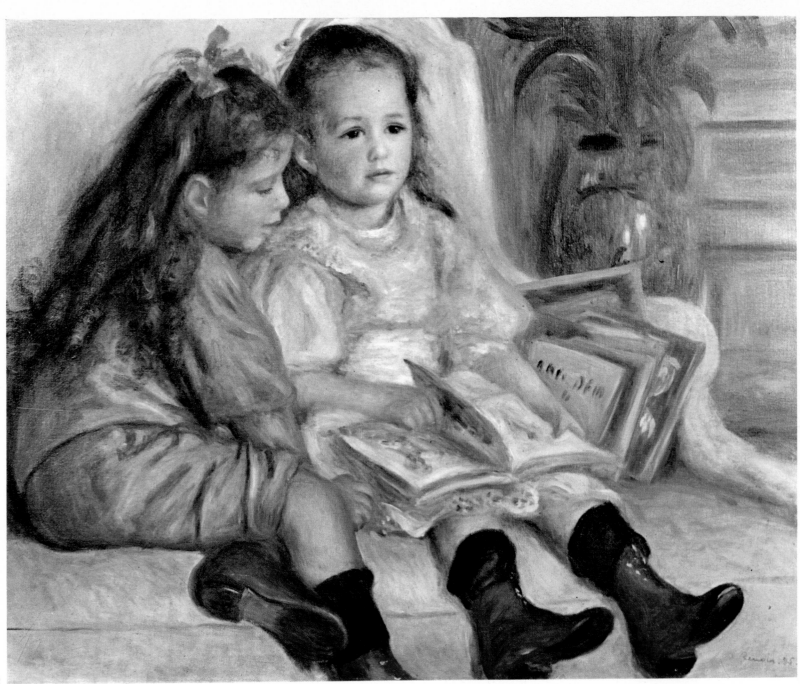

22

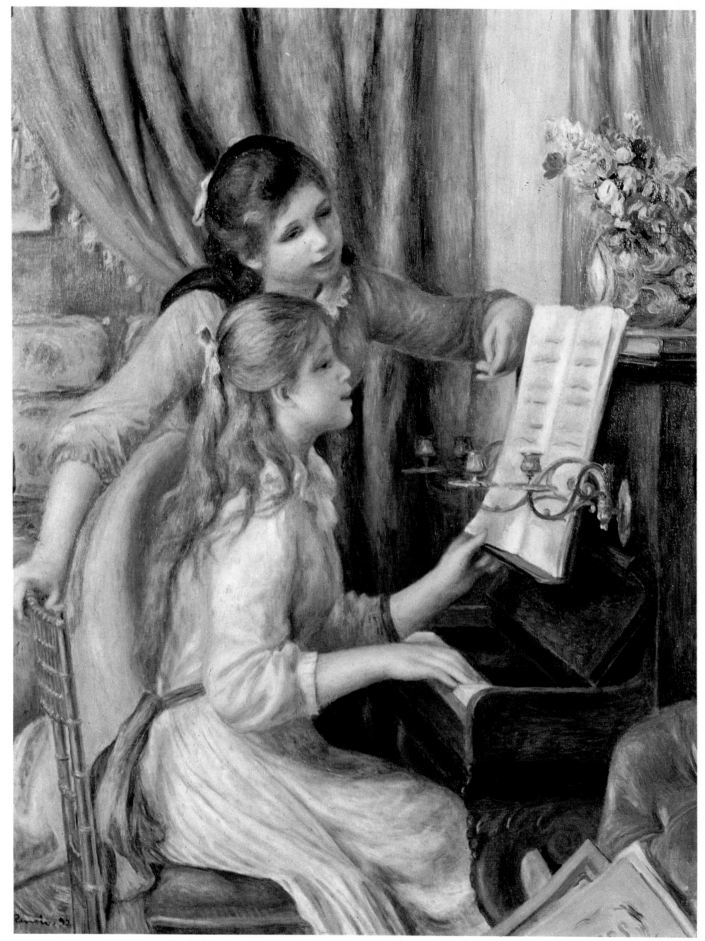

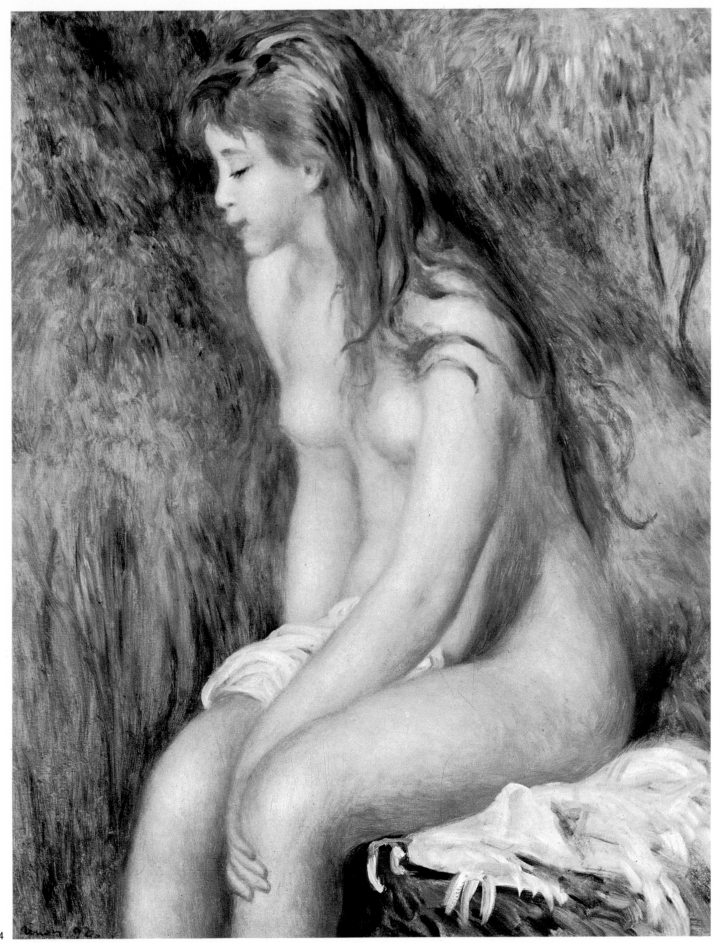

24

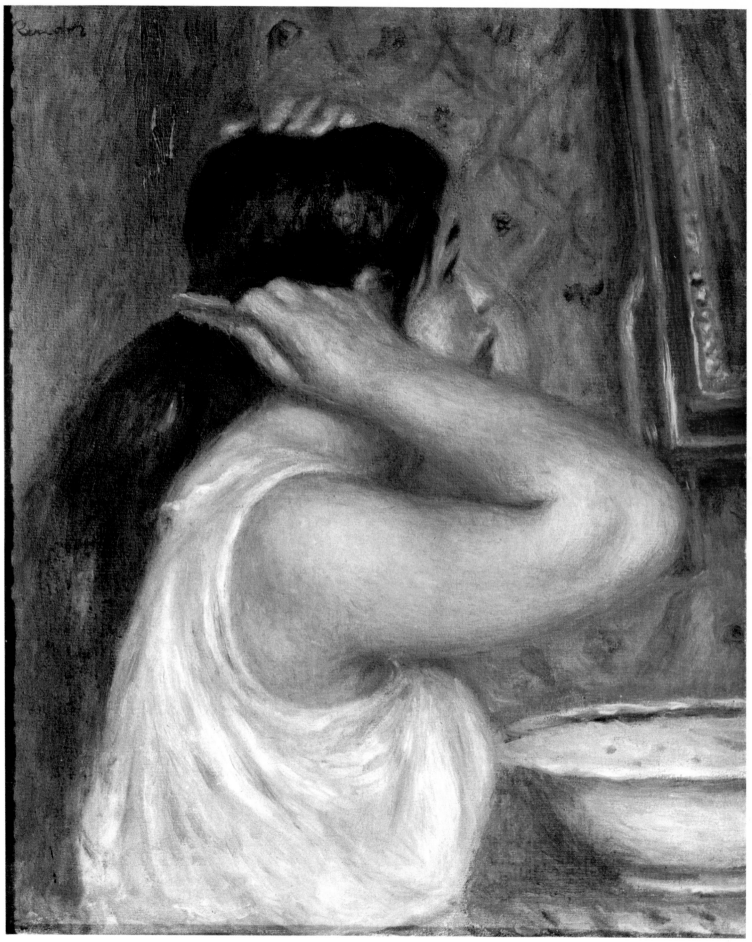

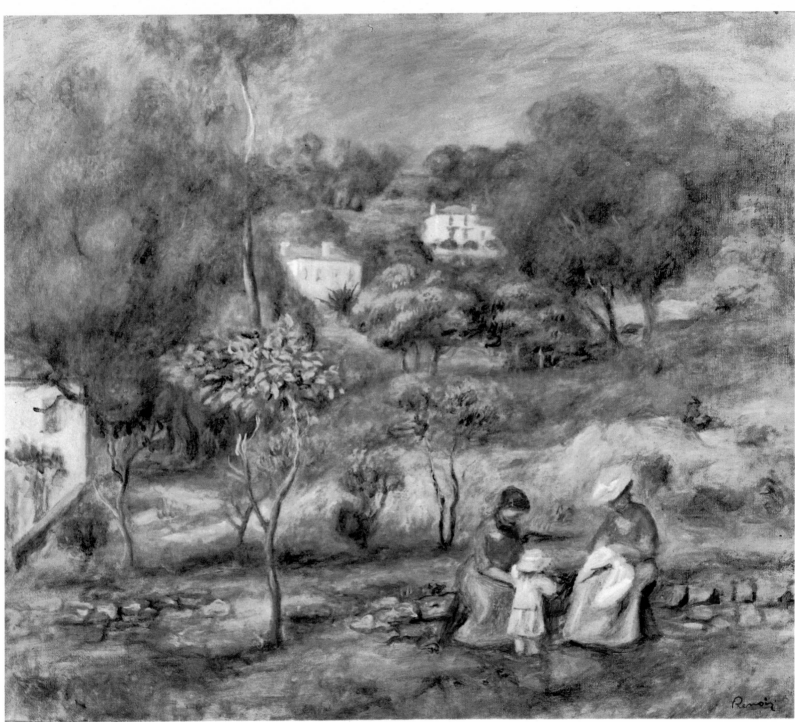

26

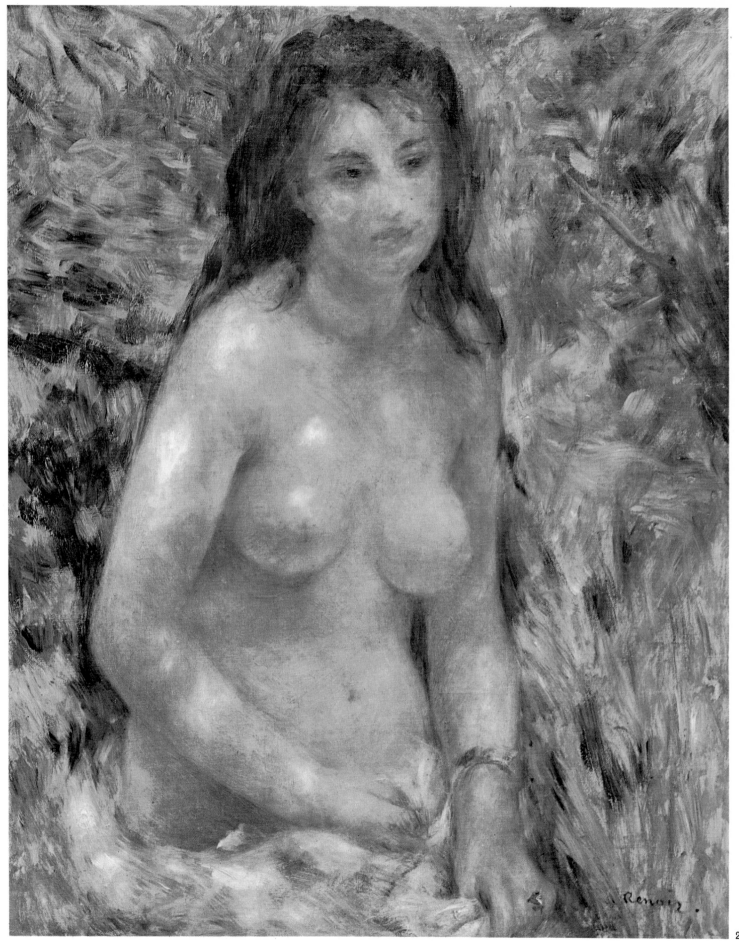

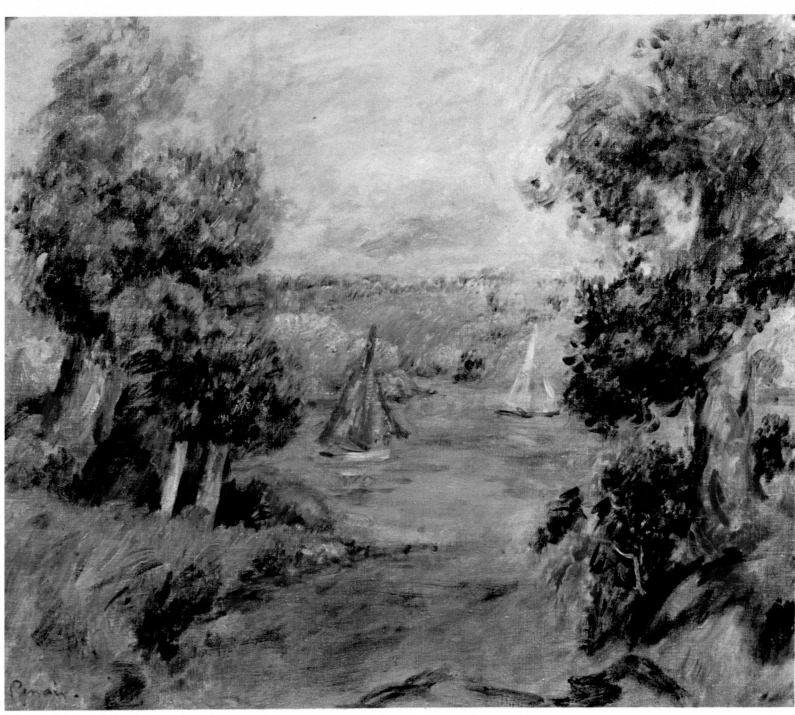

28

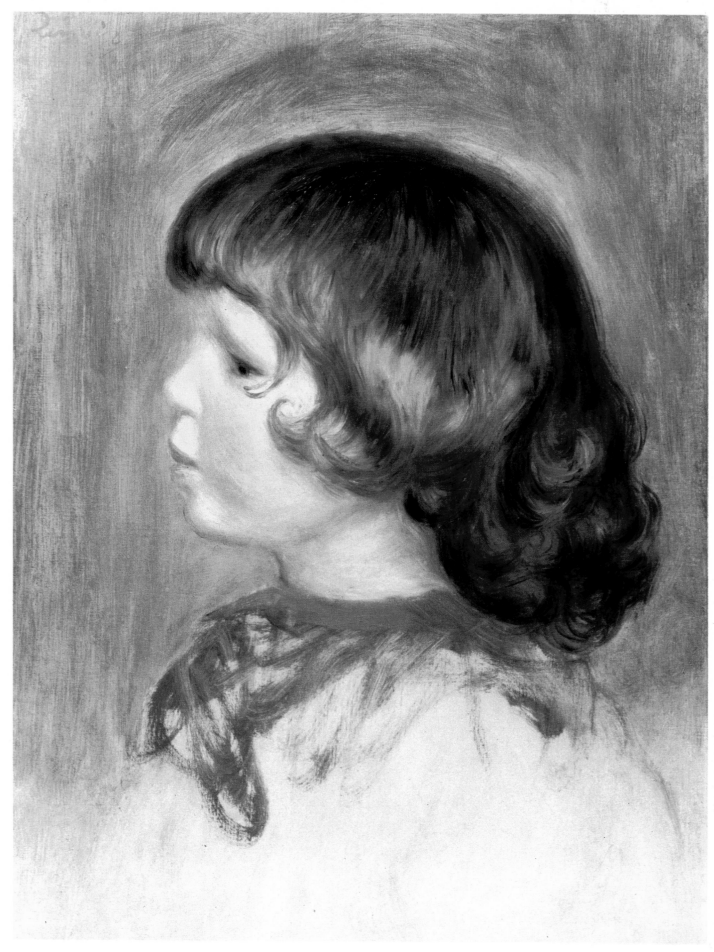

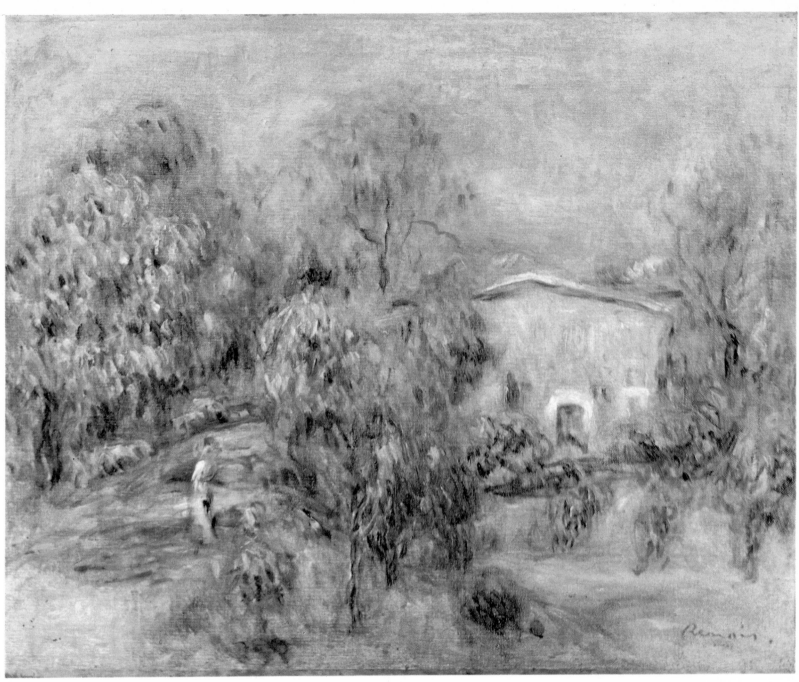

30

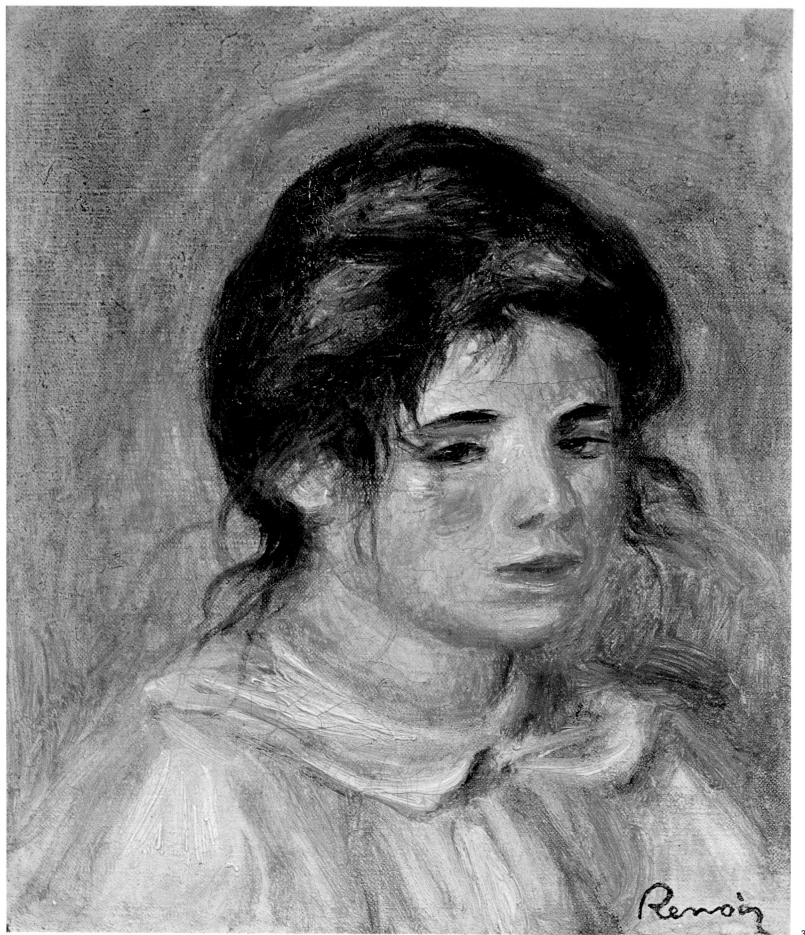

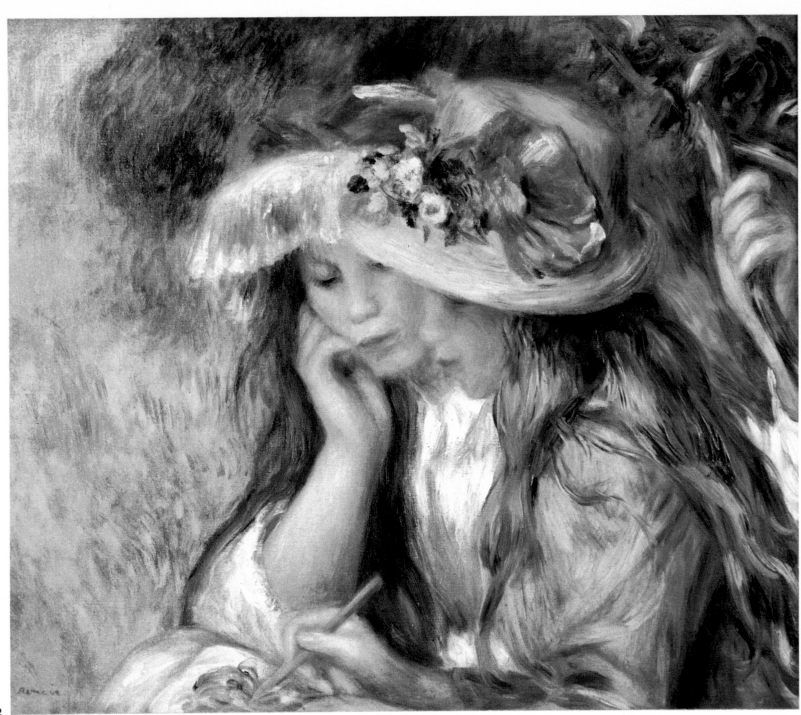

32

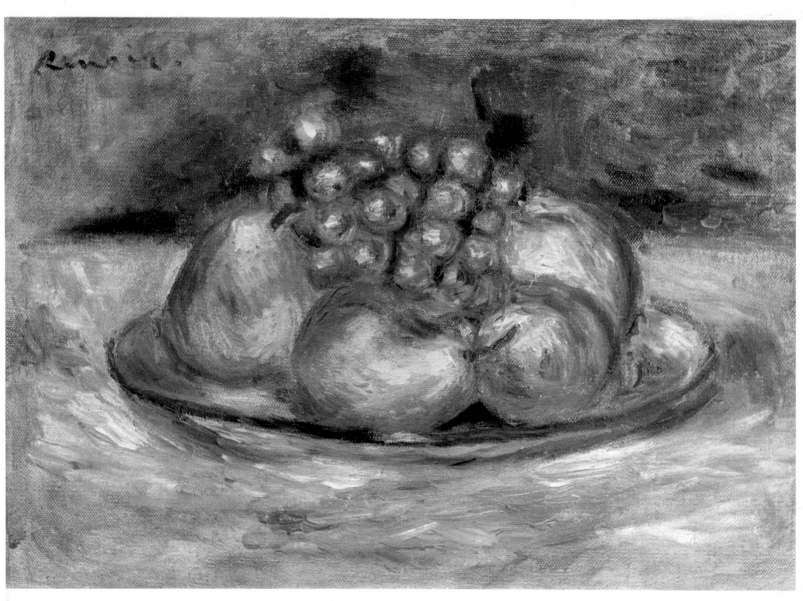

33

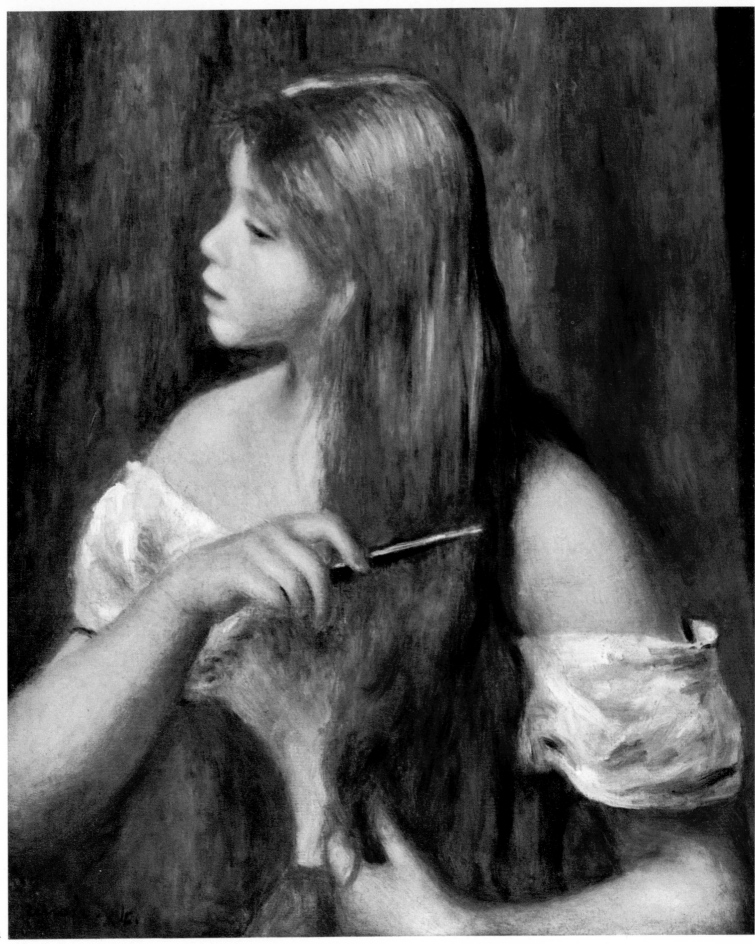

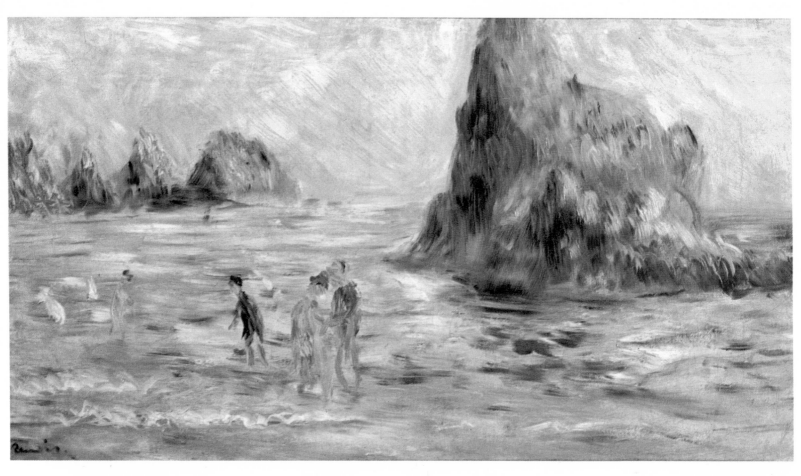

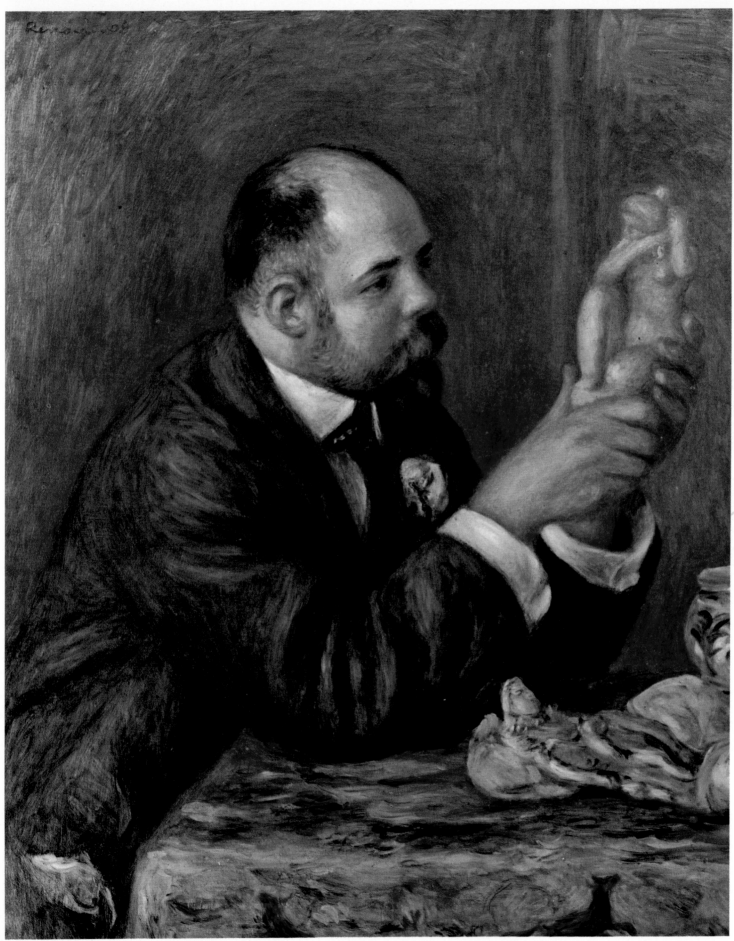

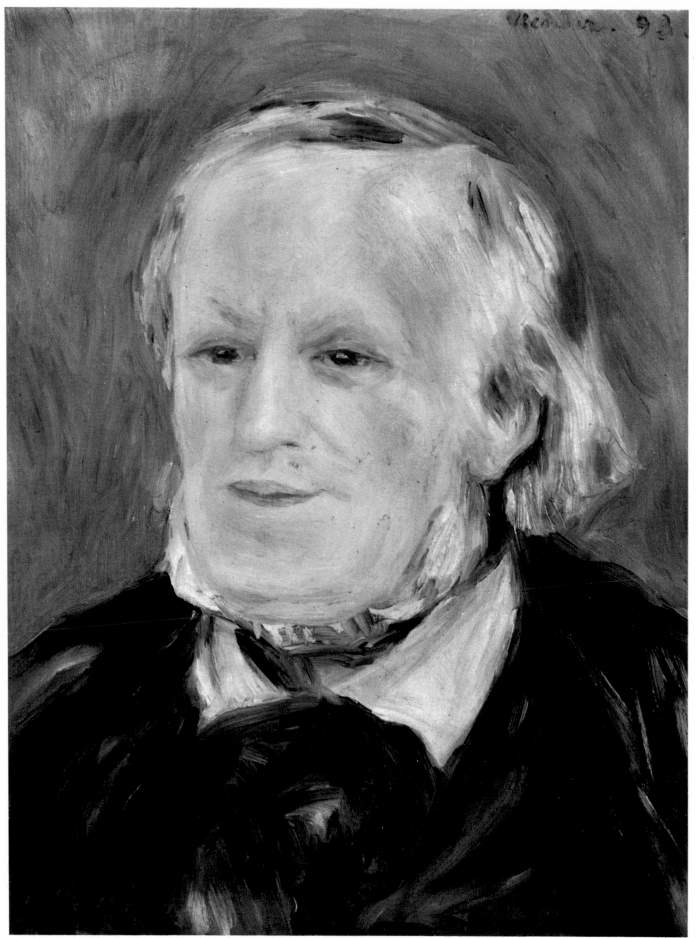

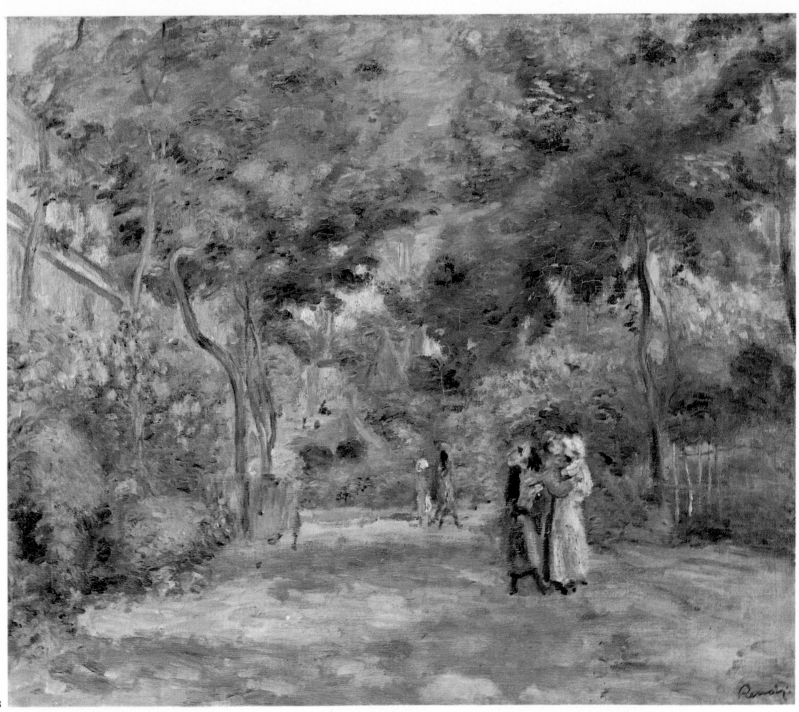

38

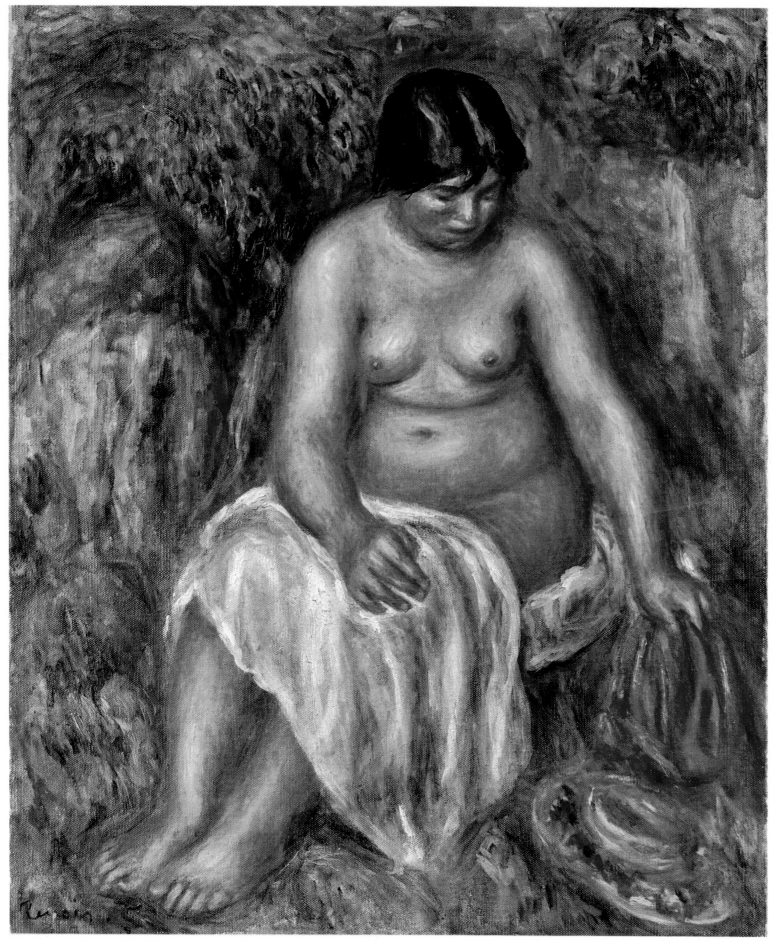

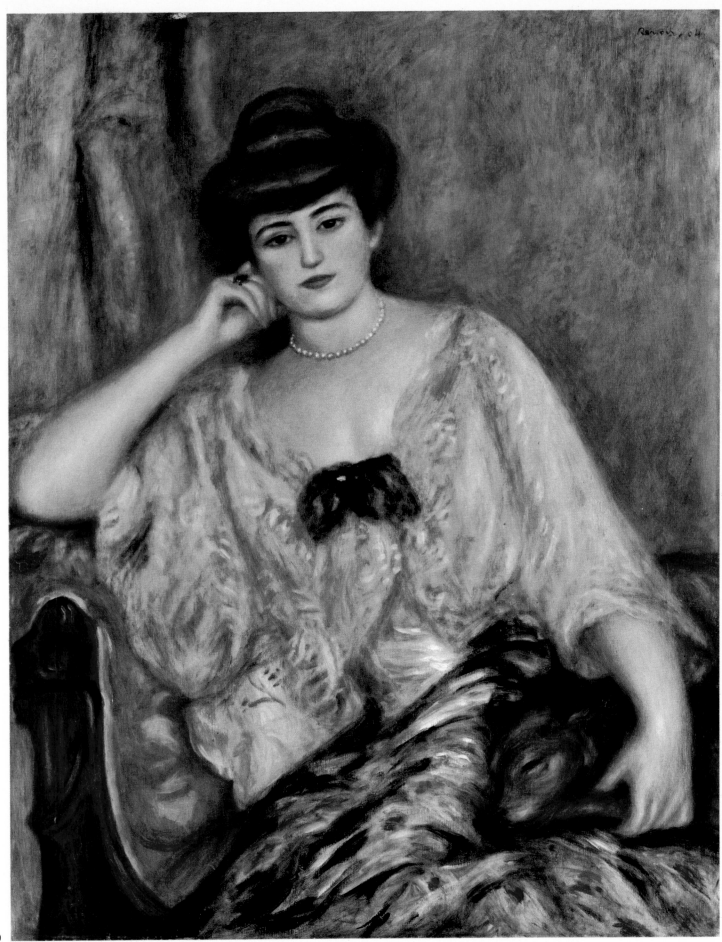

40

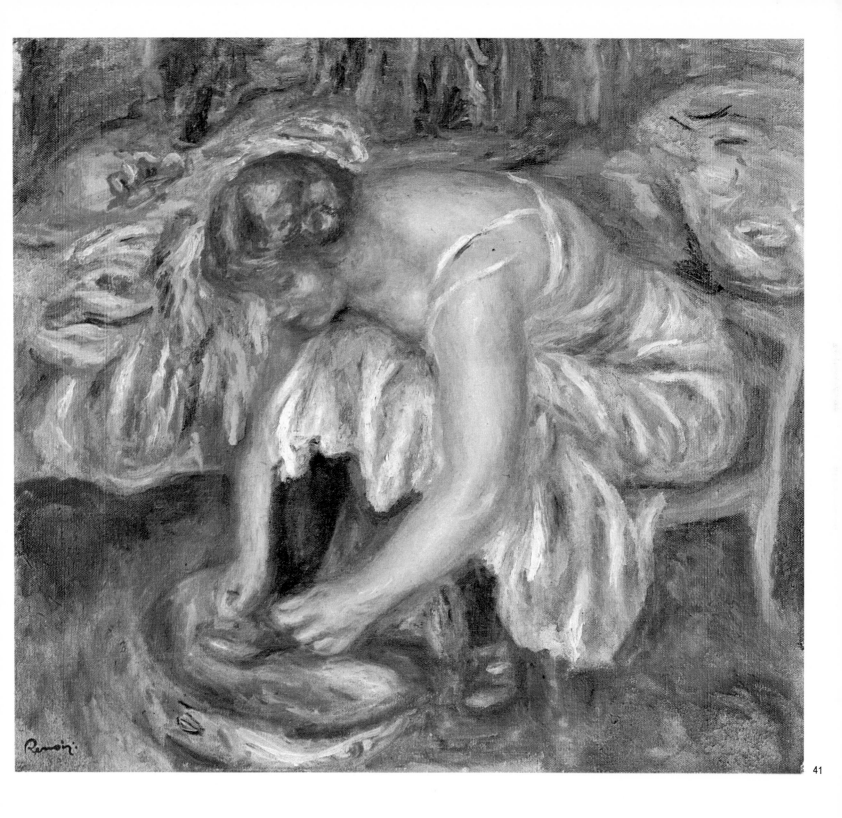

41

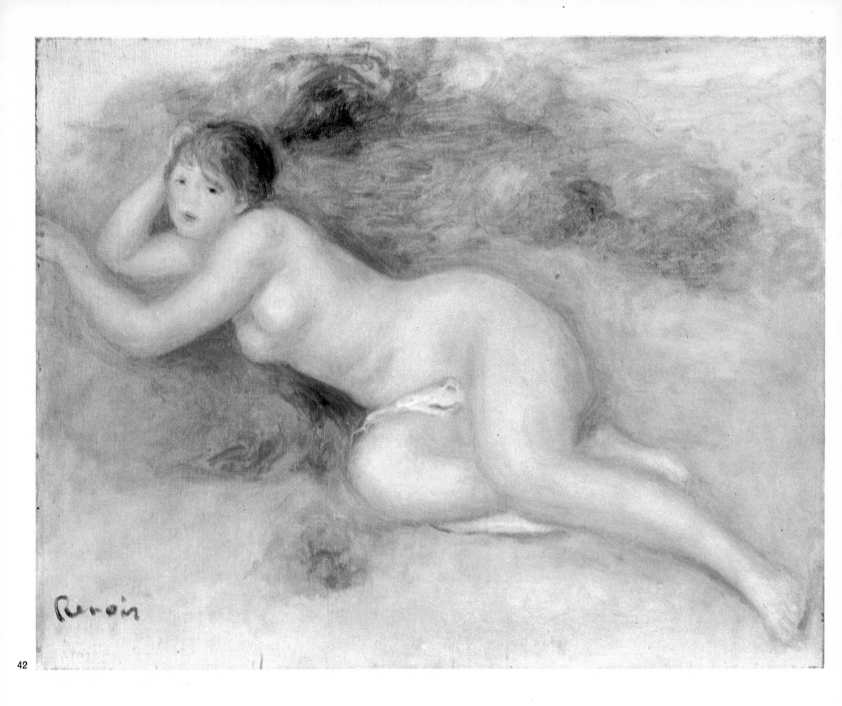

42

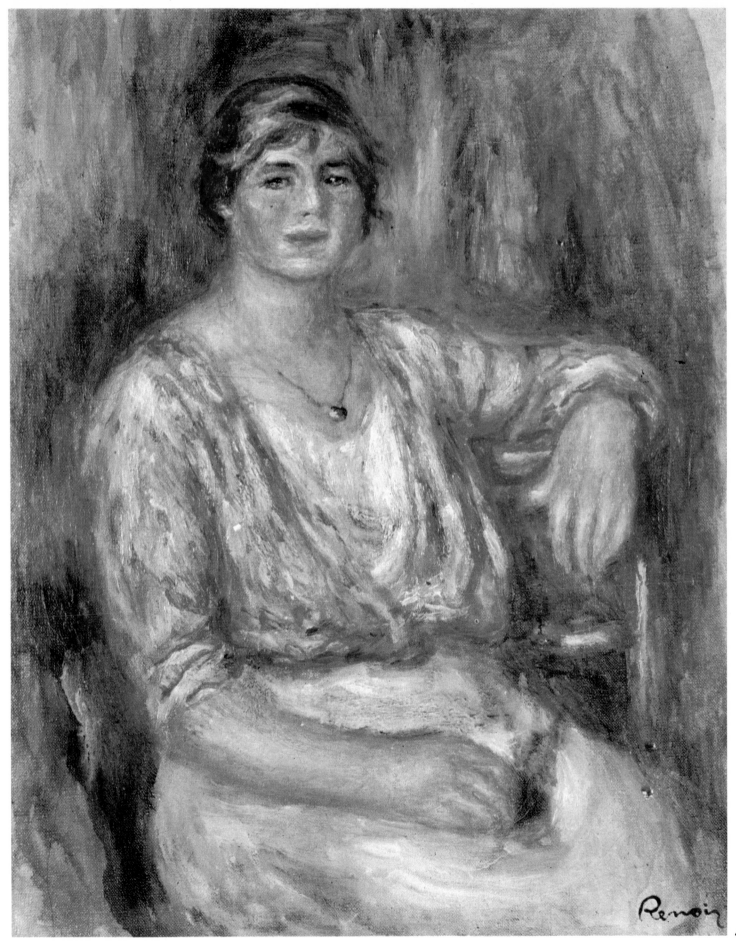

43

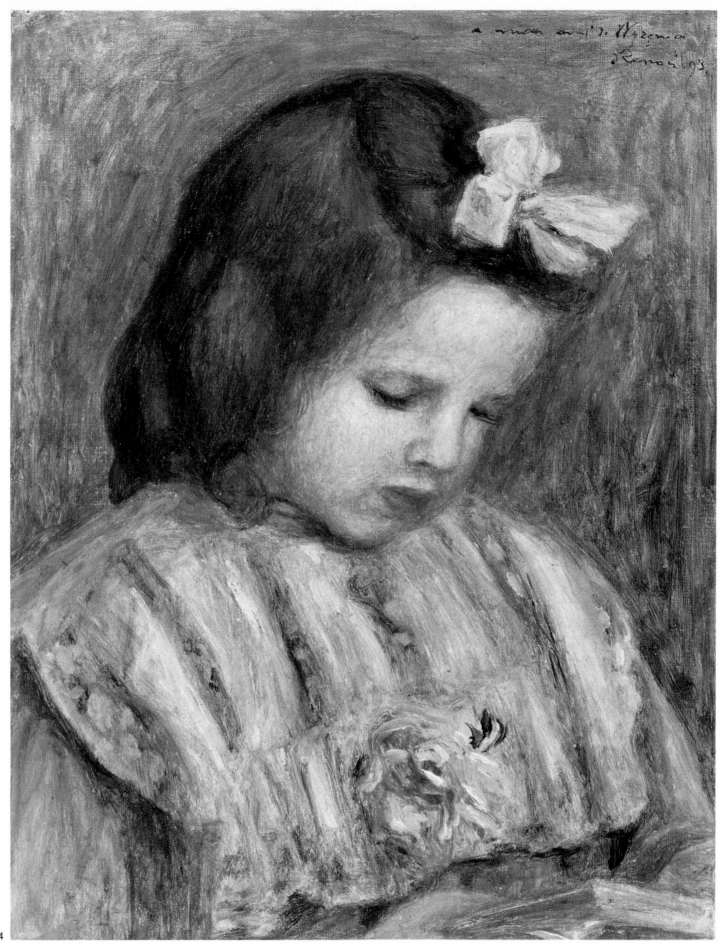

44

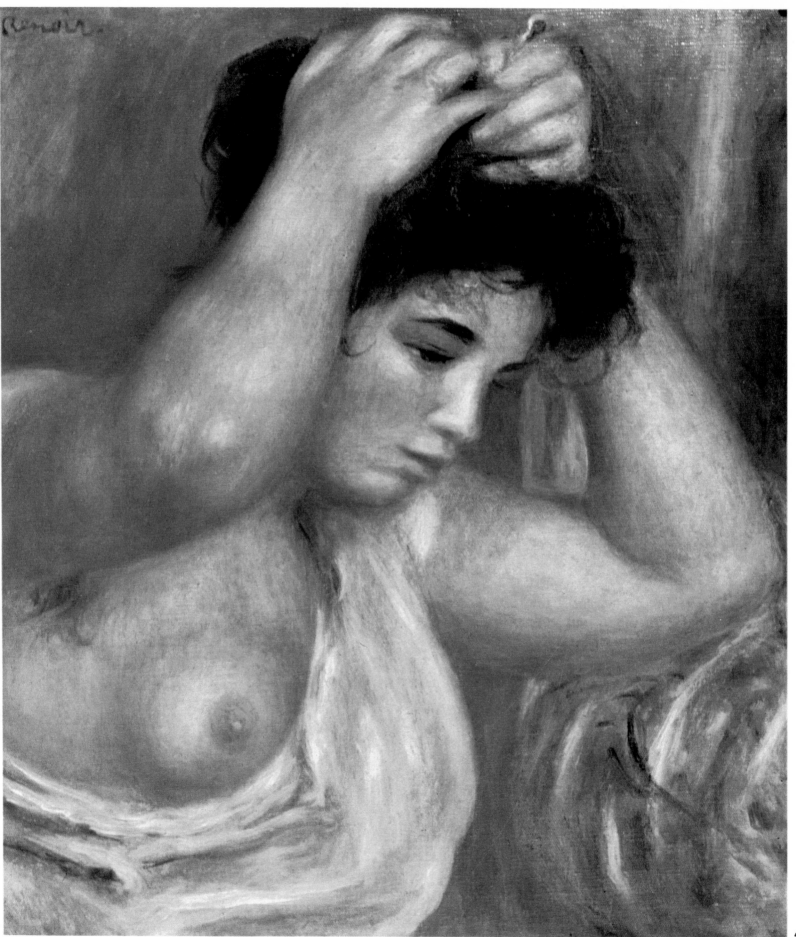

45

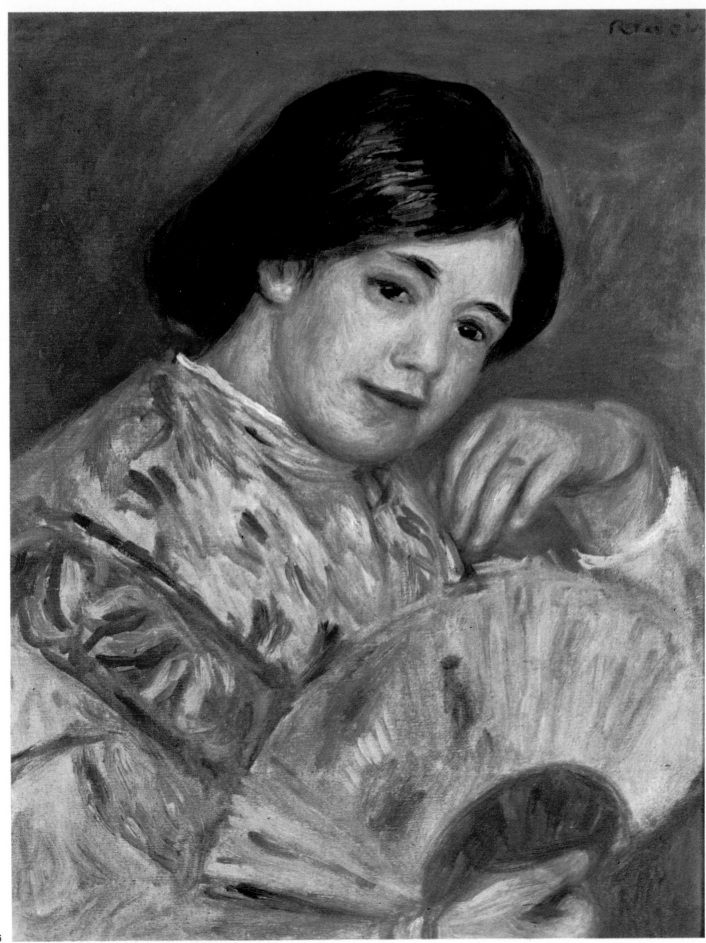

46

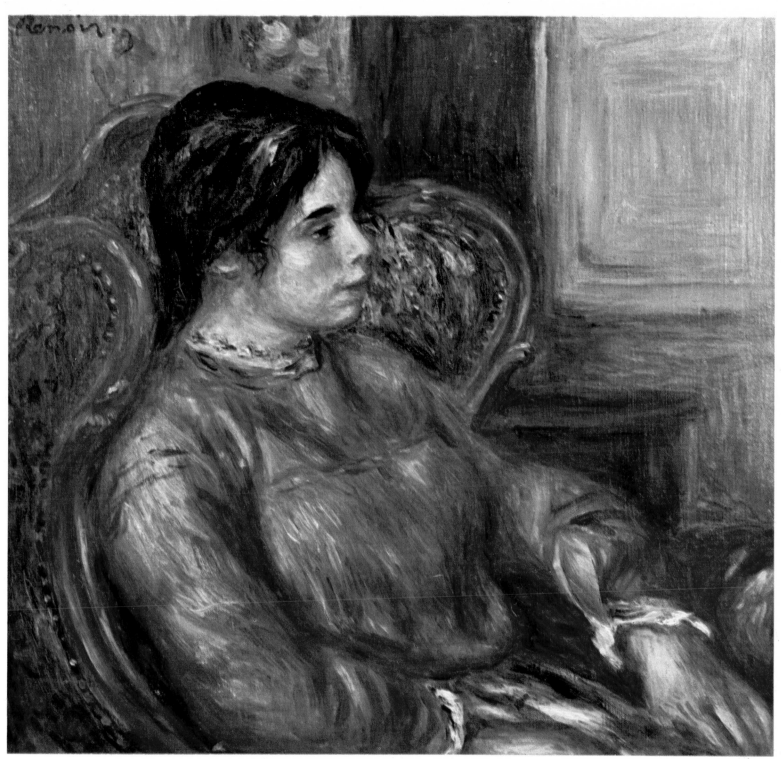

47

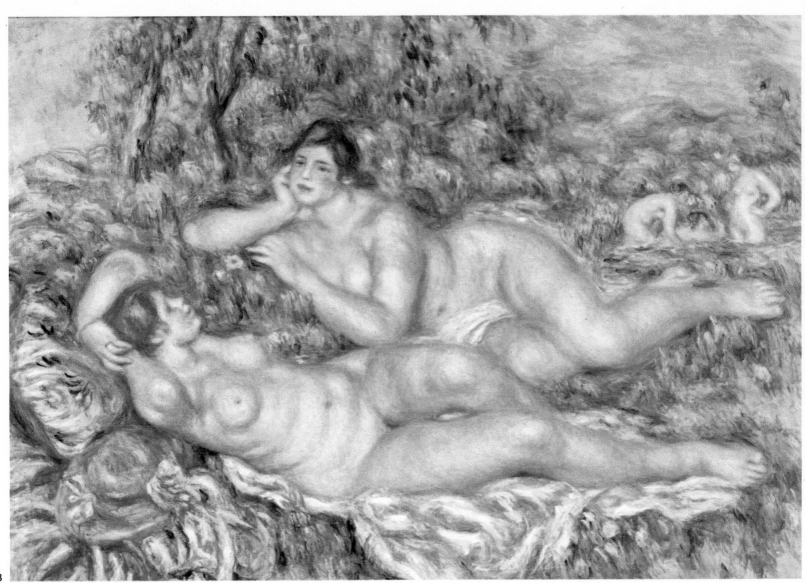

48